Animals Coloring Book For Adults

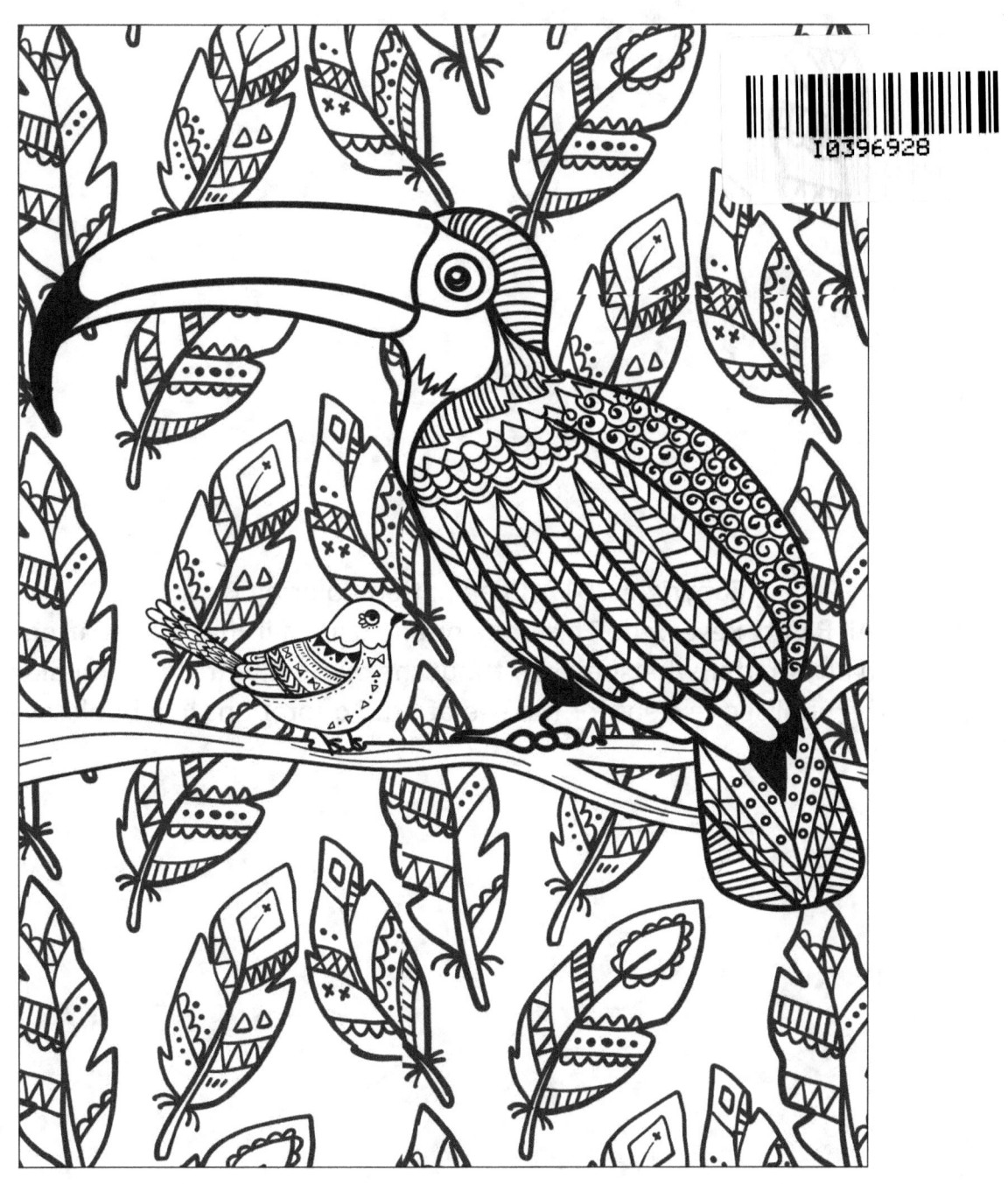

Stress Relieving Relaxation Coloring Book
With 41 Animal Designs

Copyright 2017 'Imagination Coloring Books'
All Rights Reserved. This book or any part of it may not be used
in any matter whatsoever without the express written permission
of the publisher except for the use of brief quotations in a book review

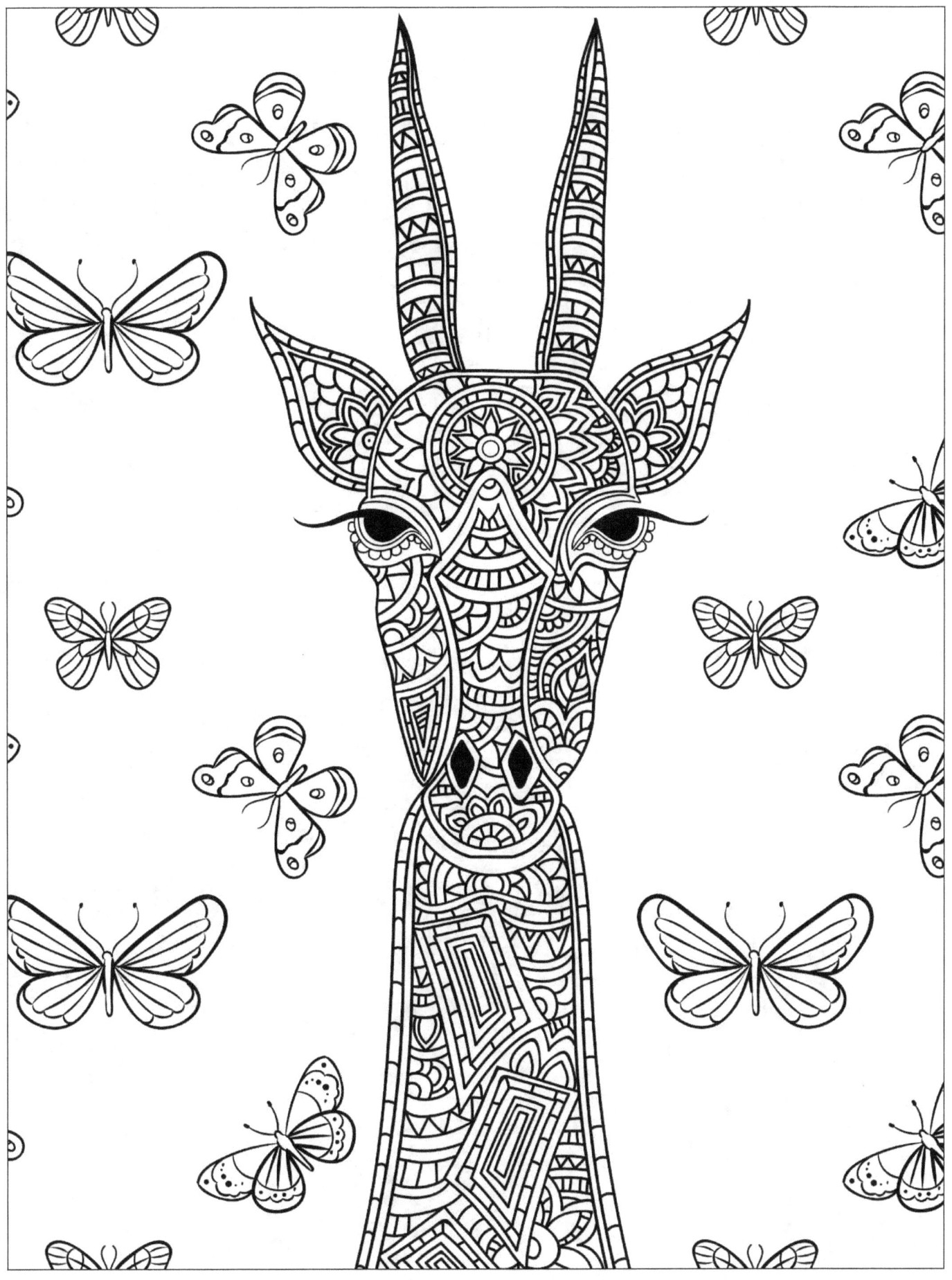

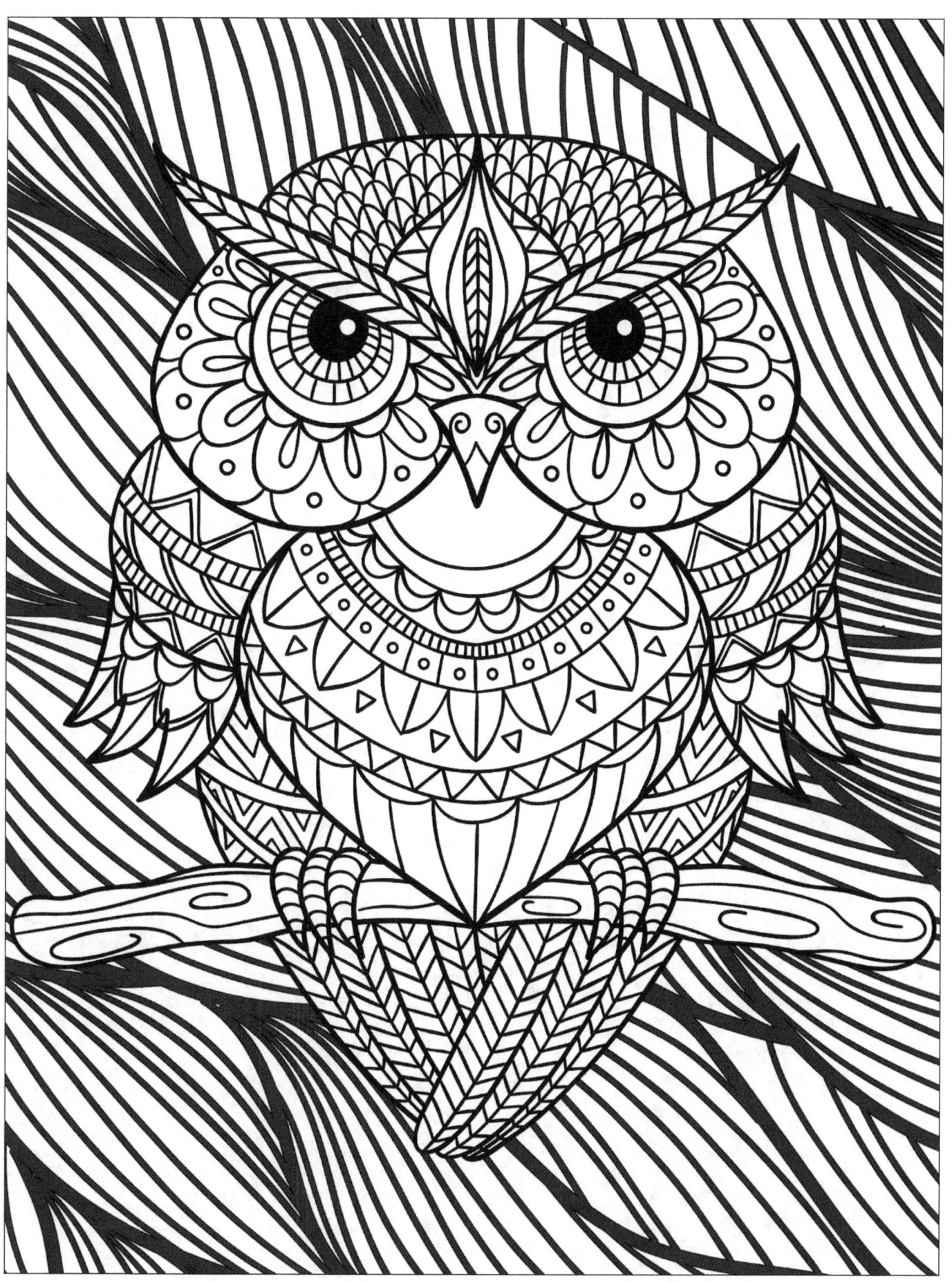

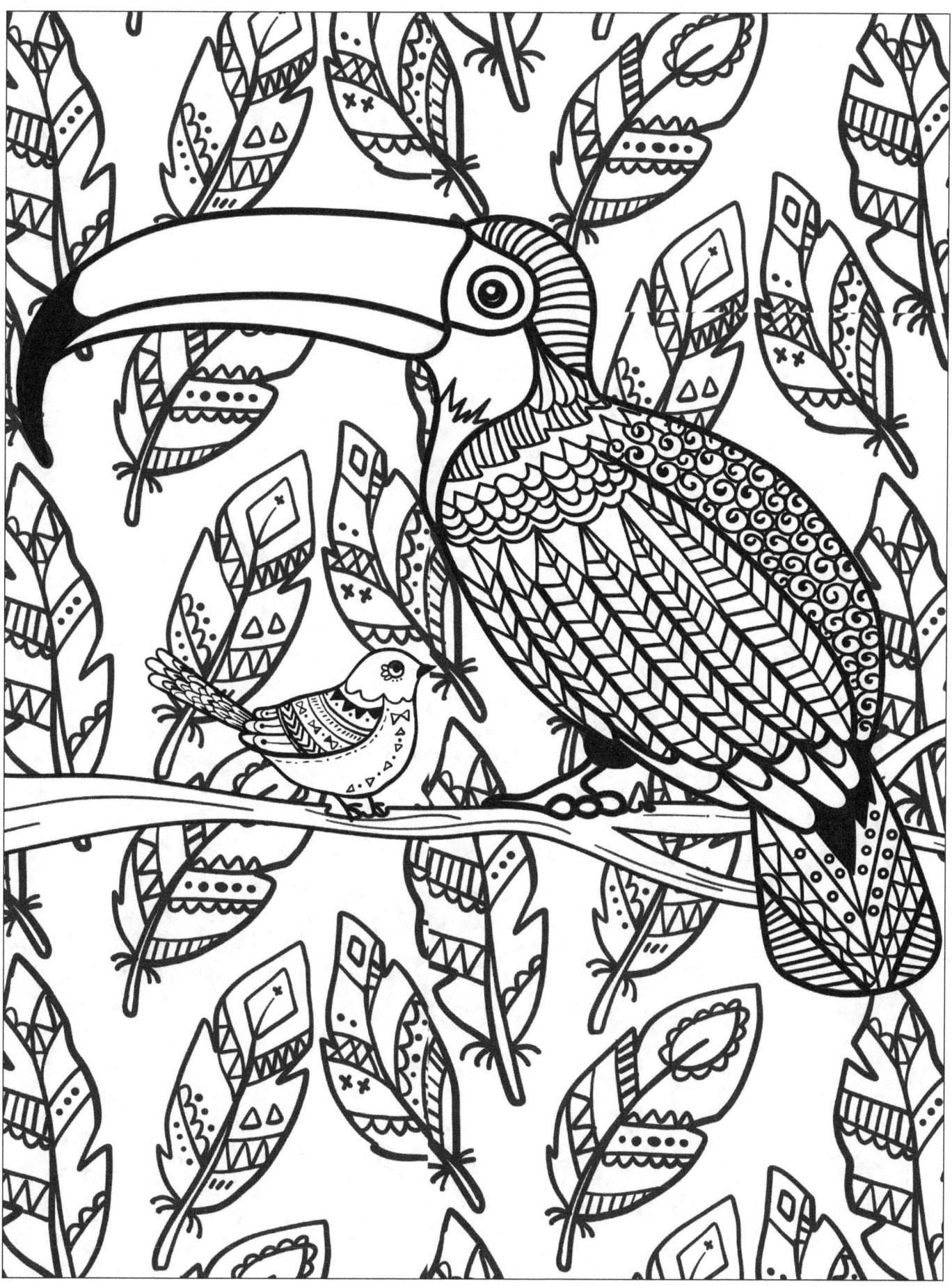

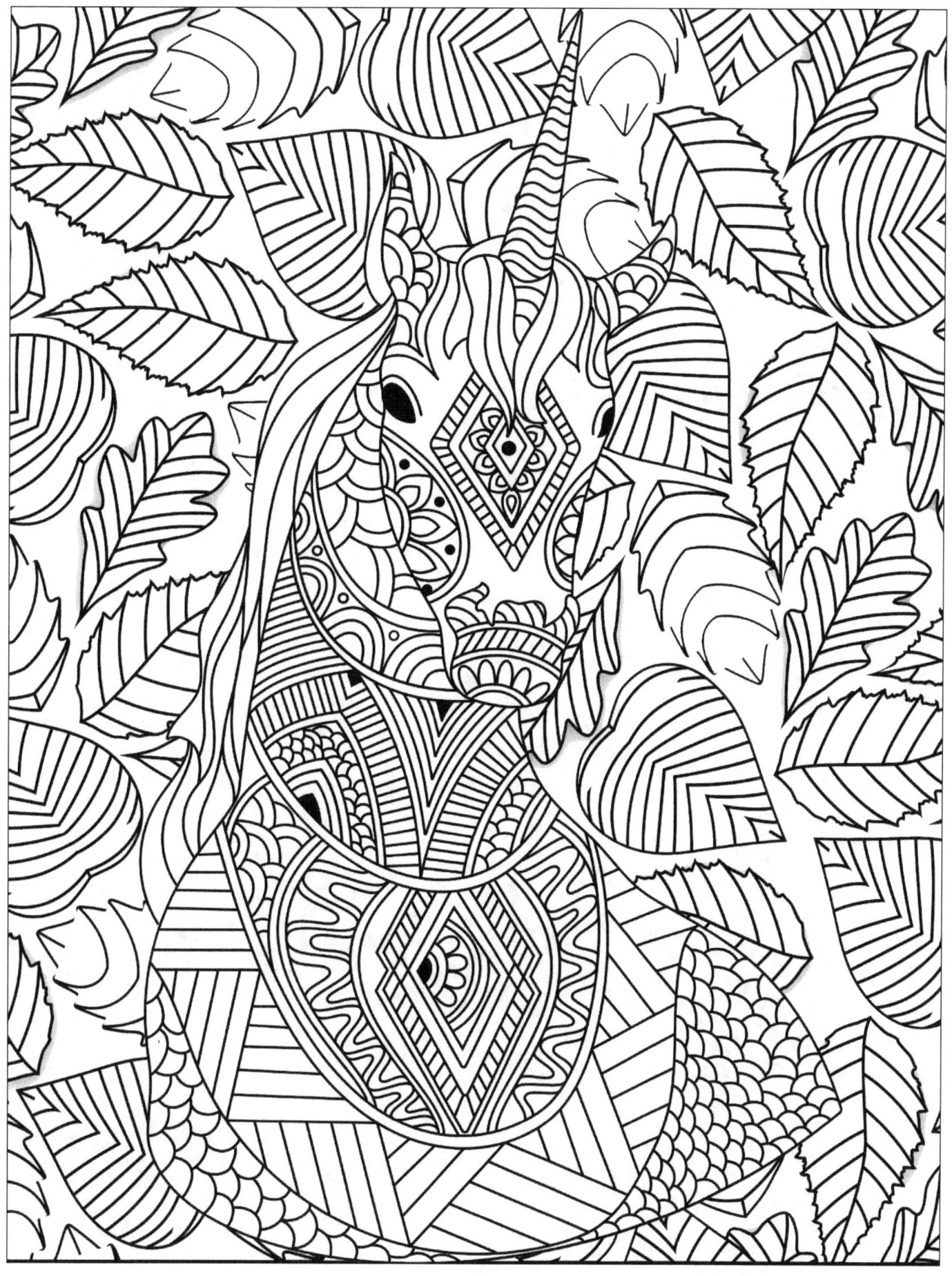

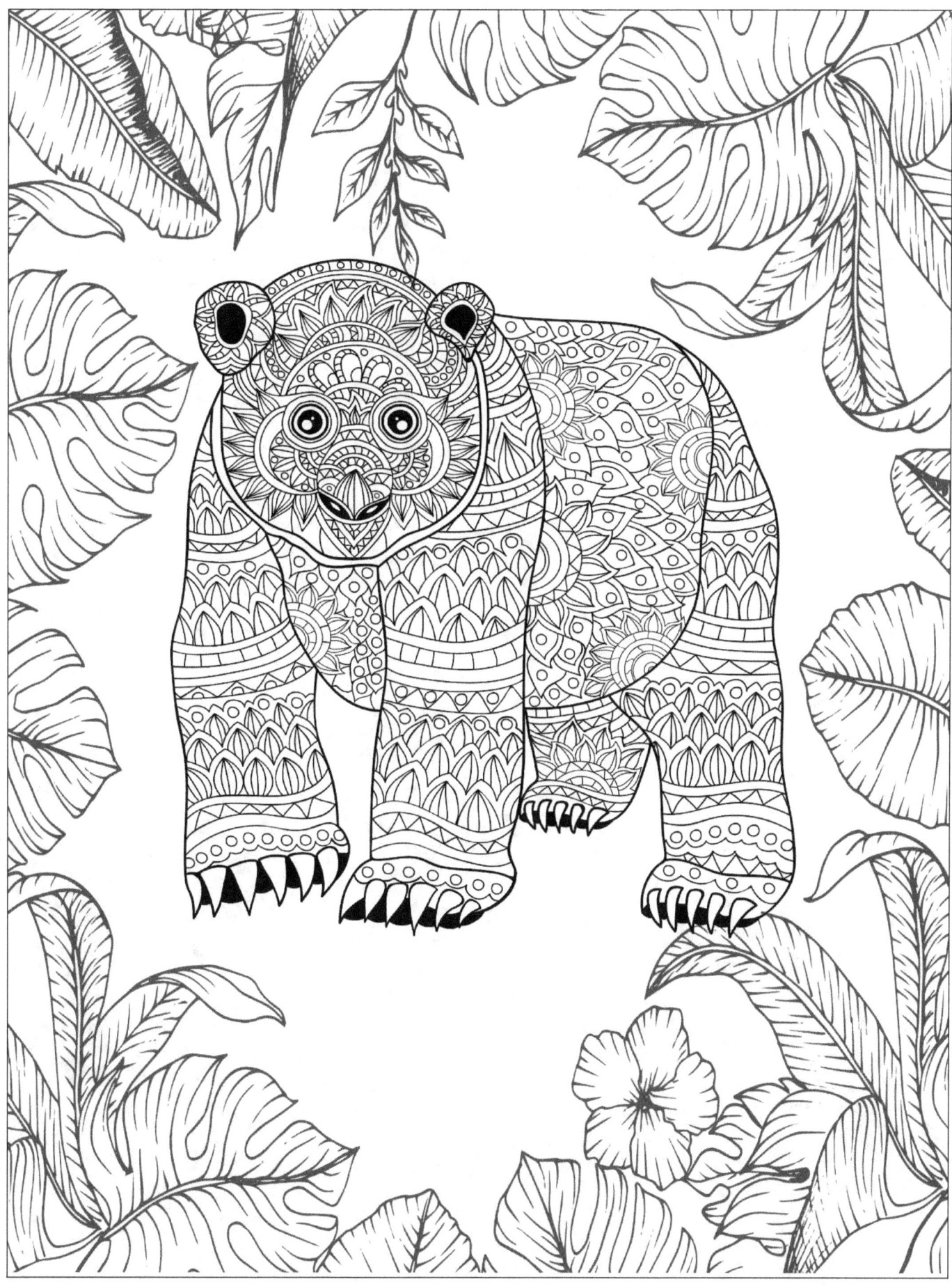

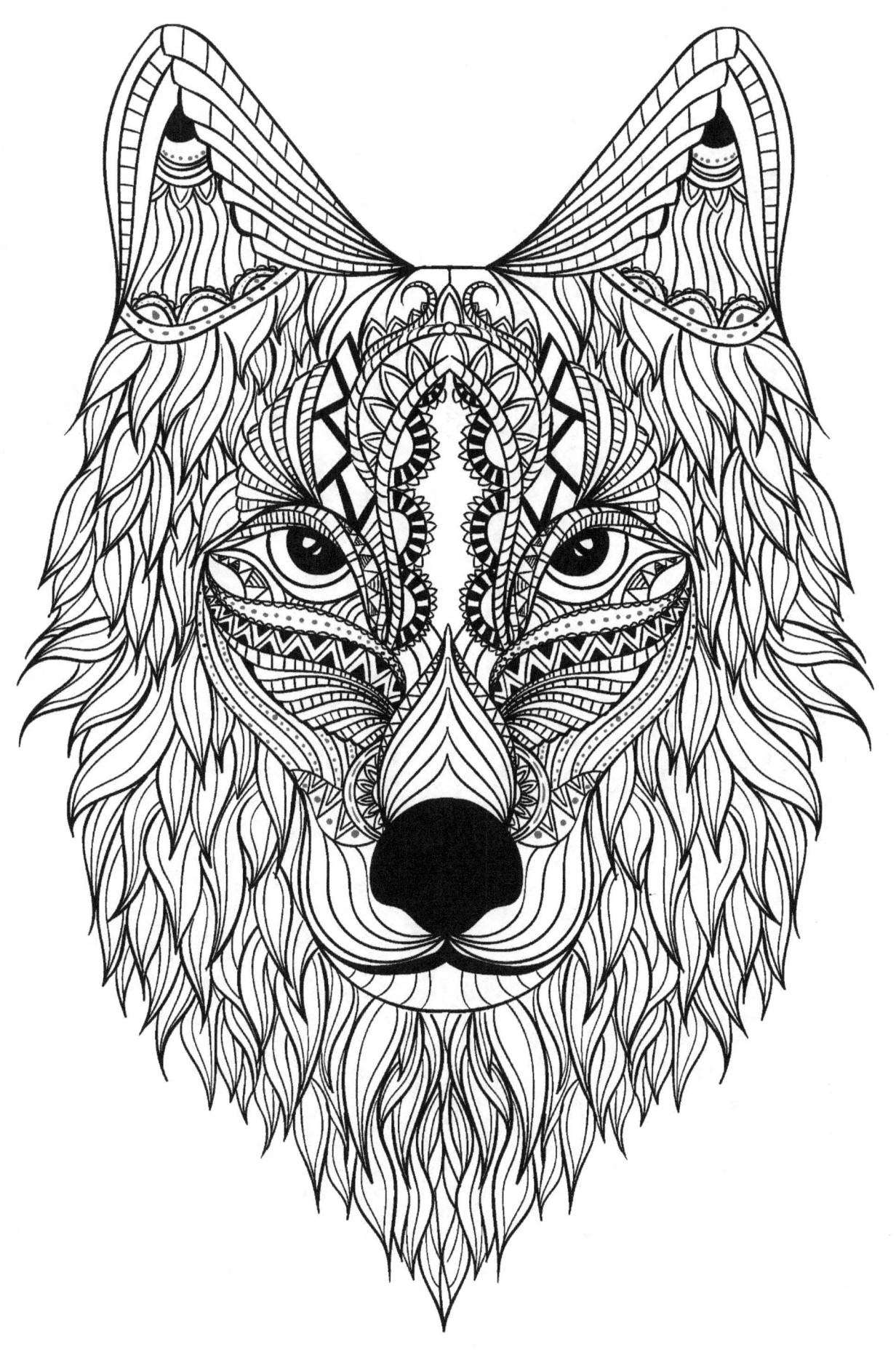

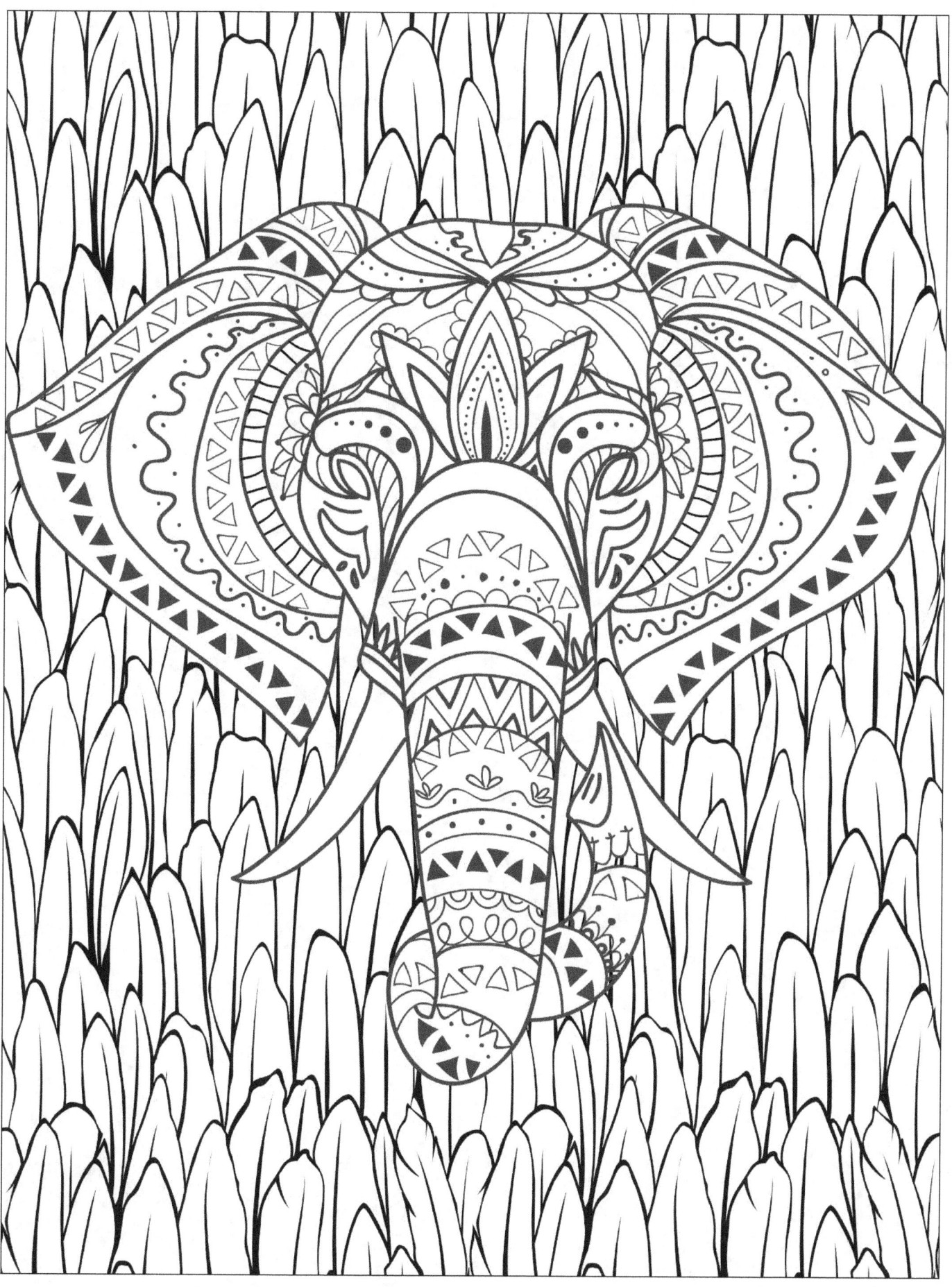

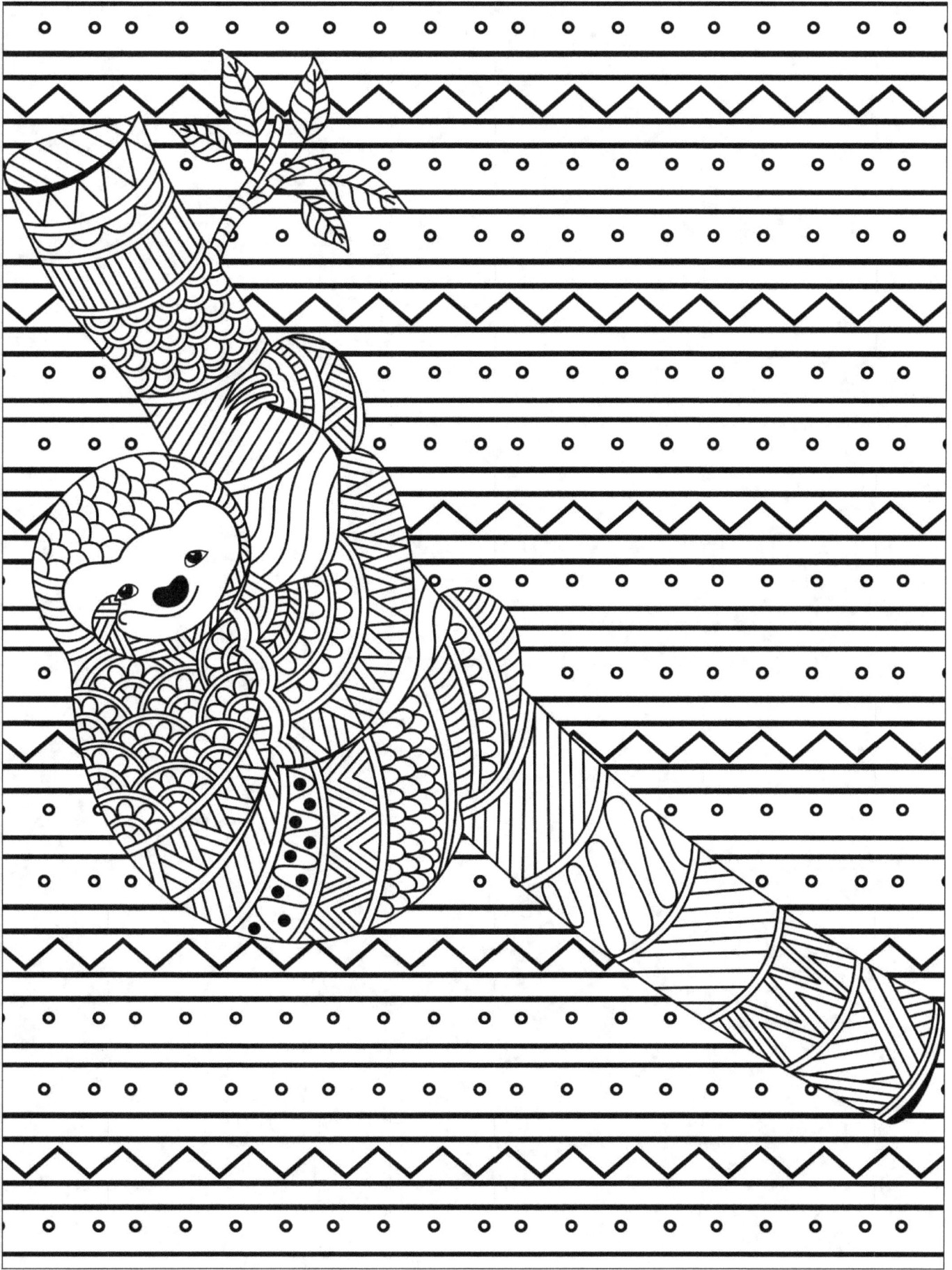

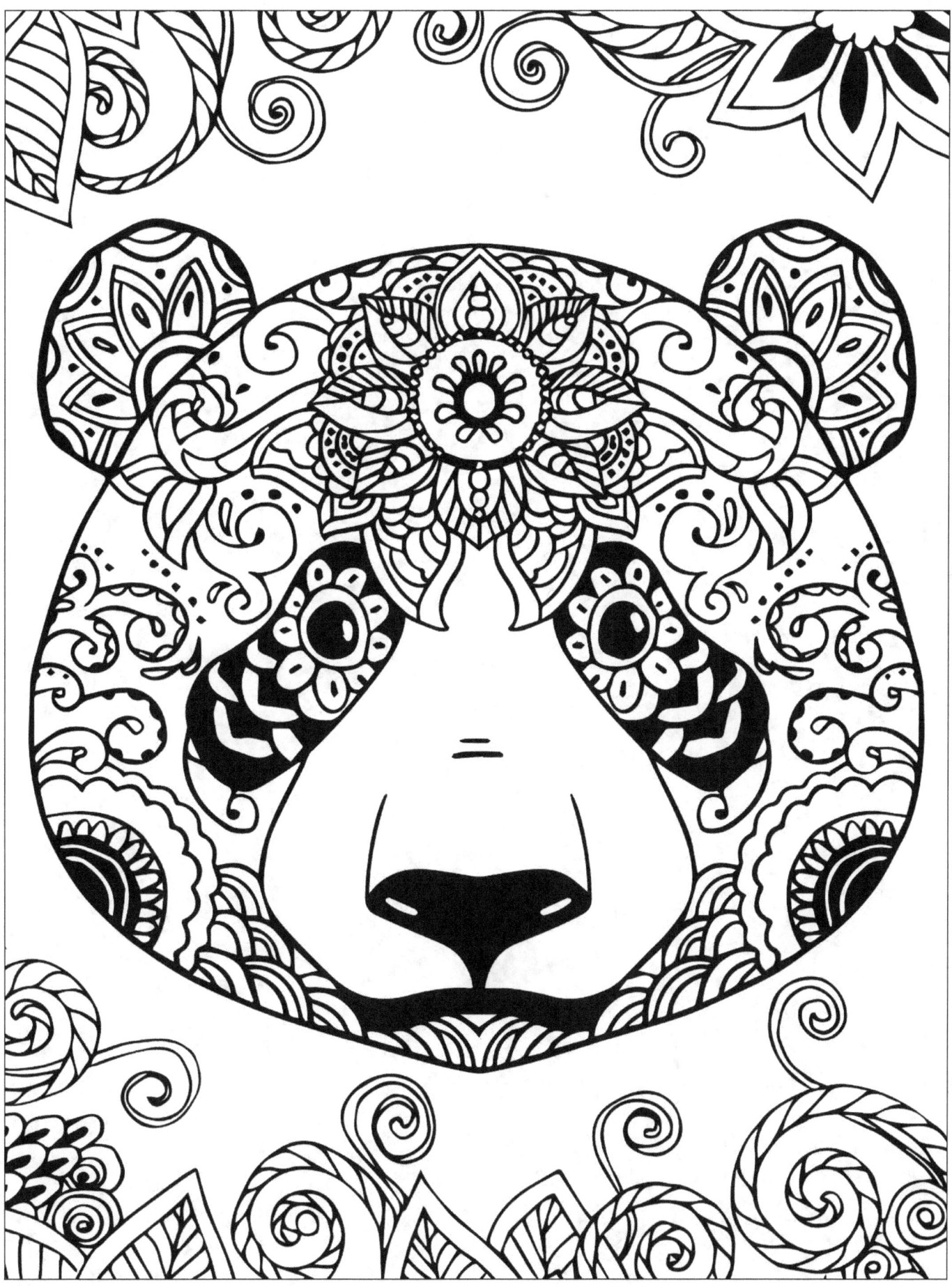

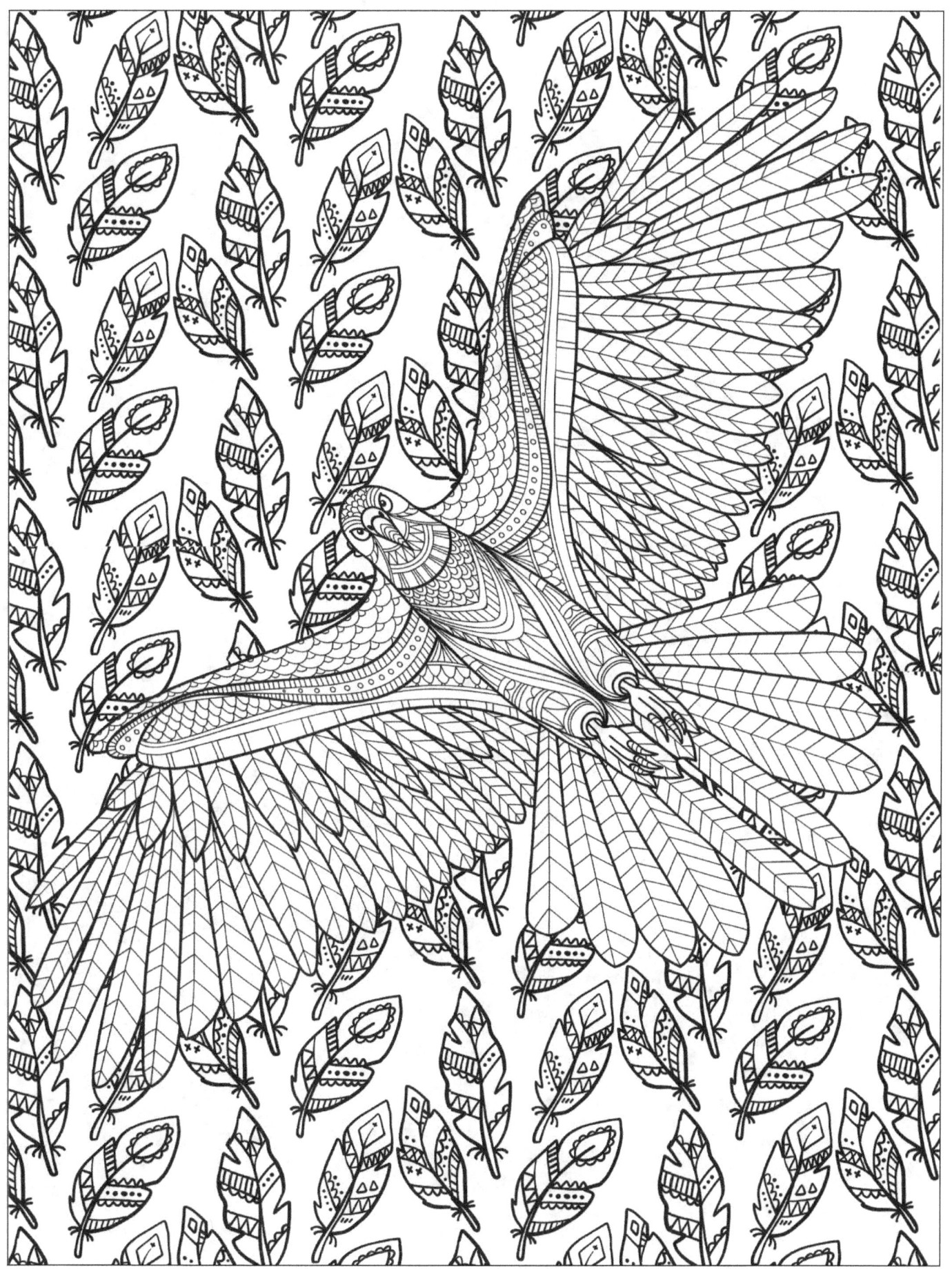

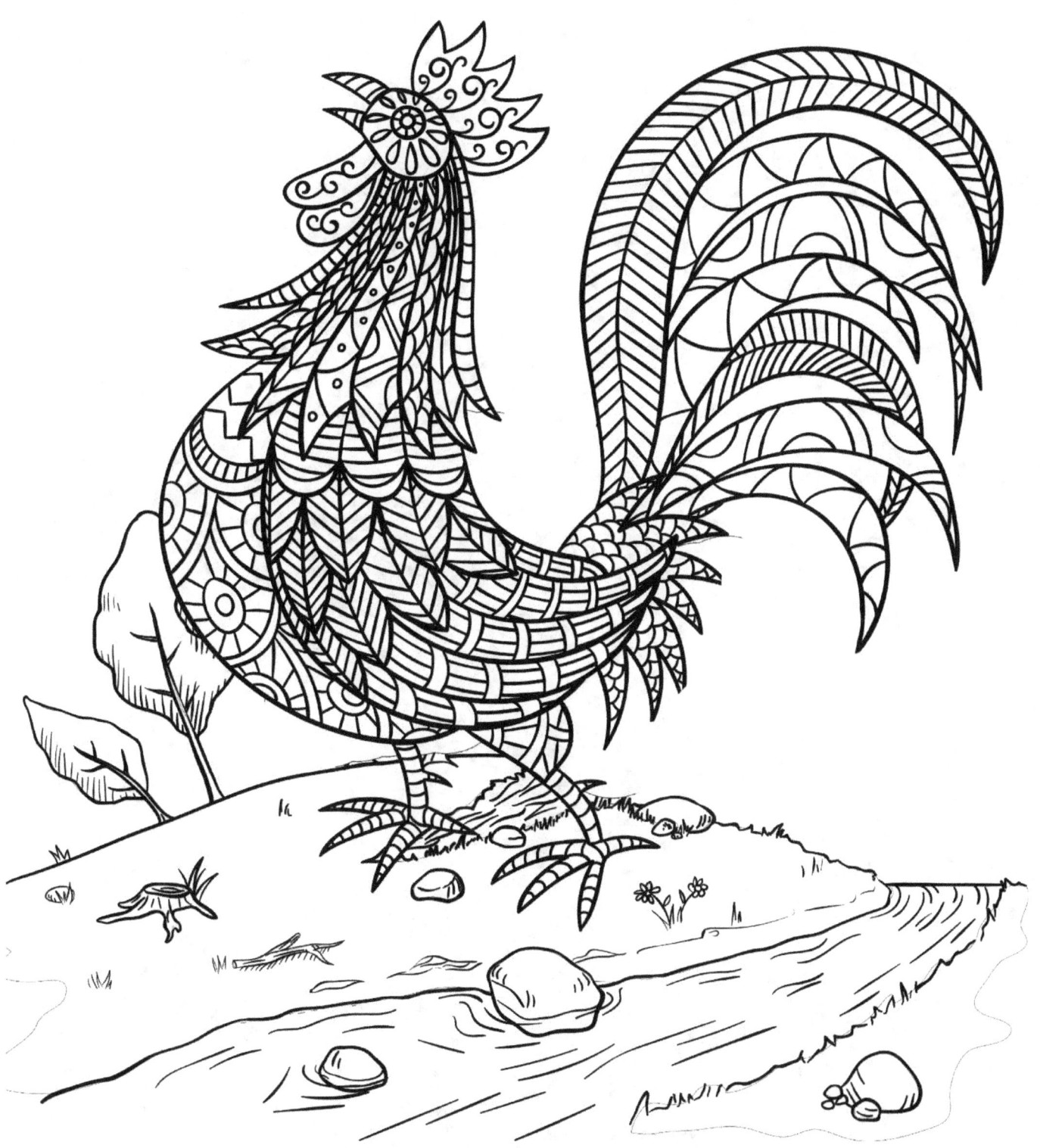

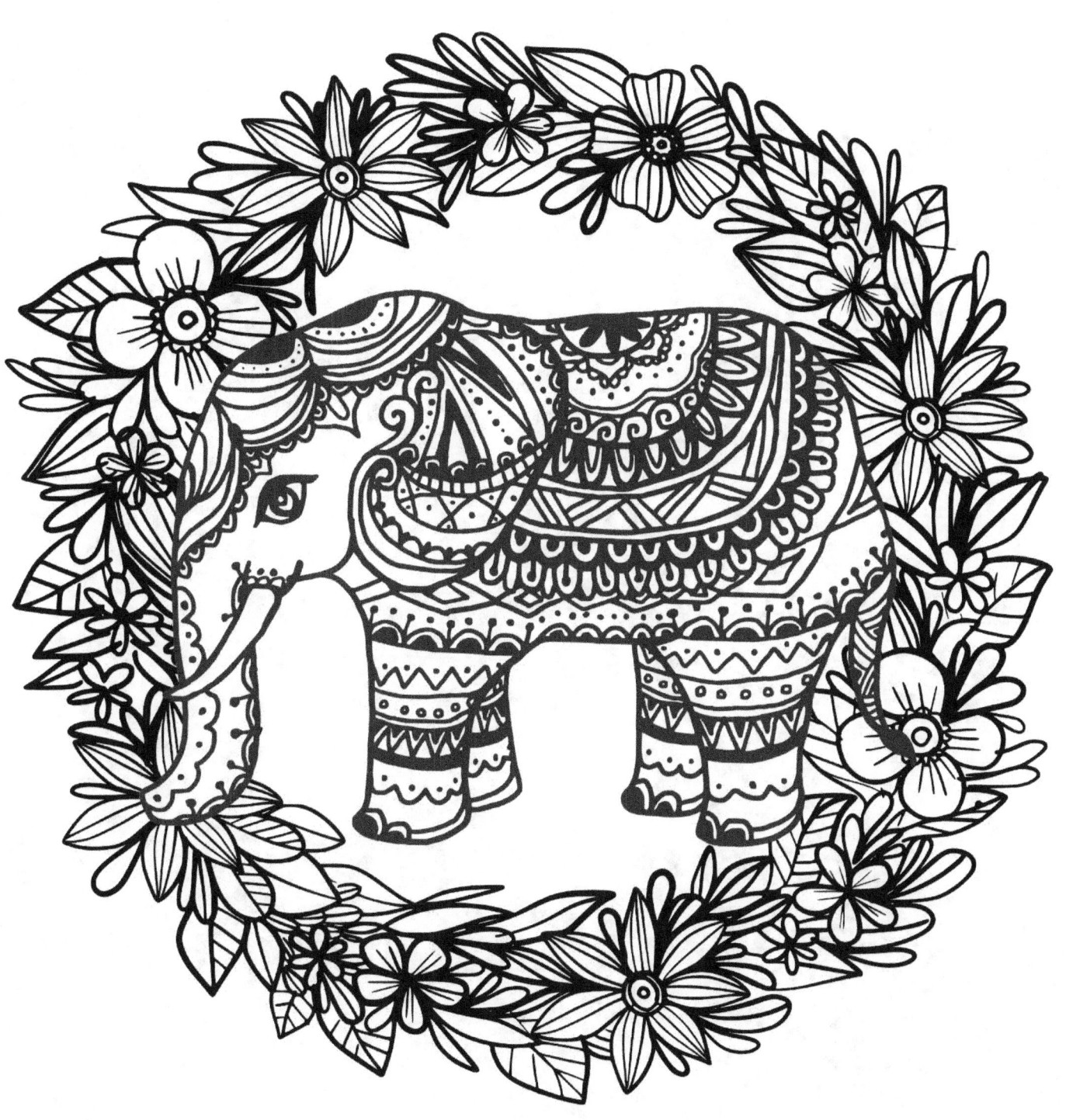

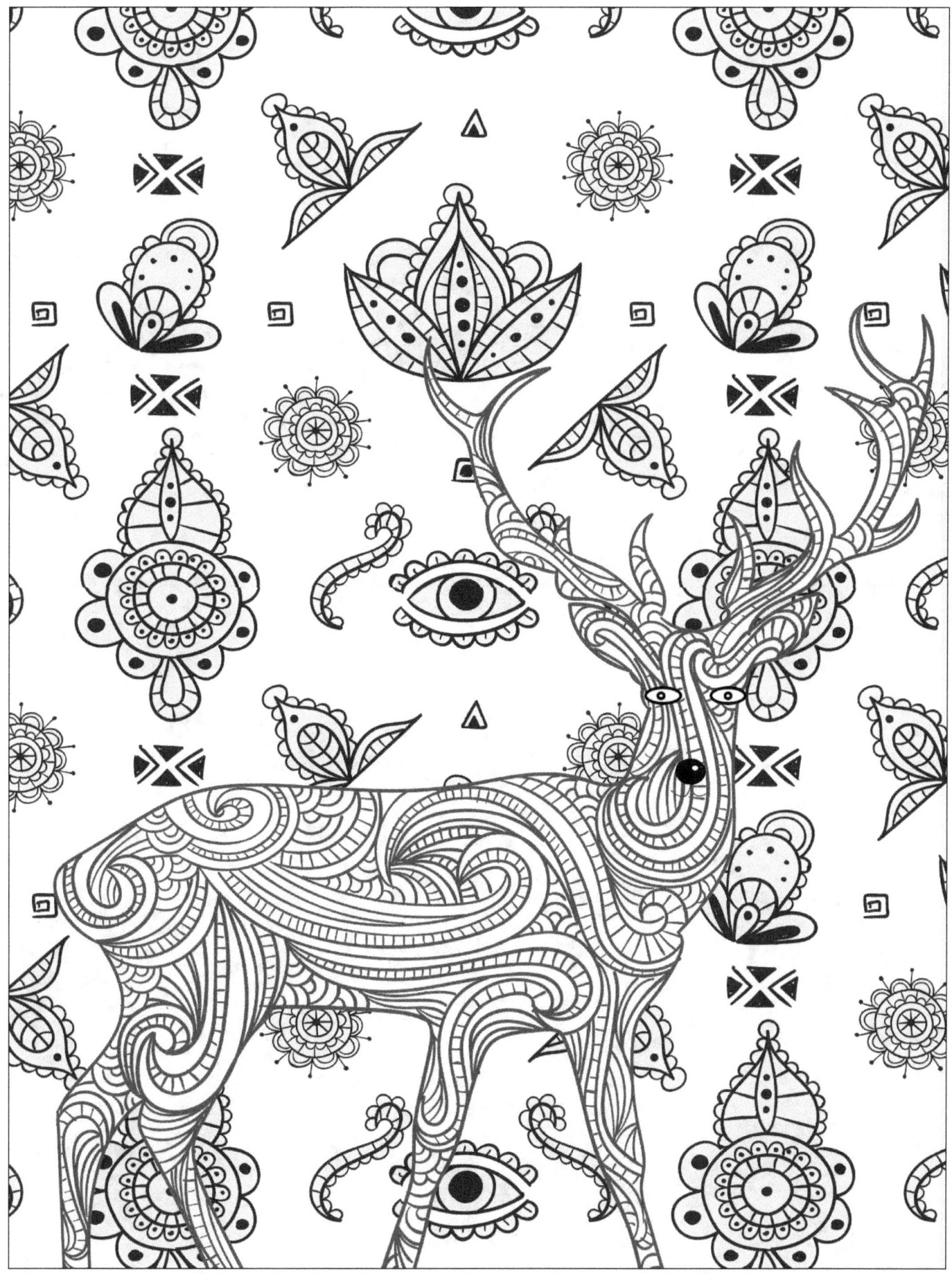

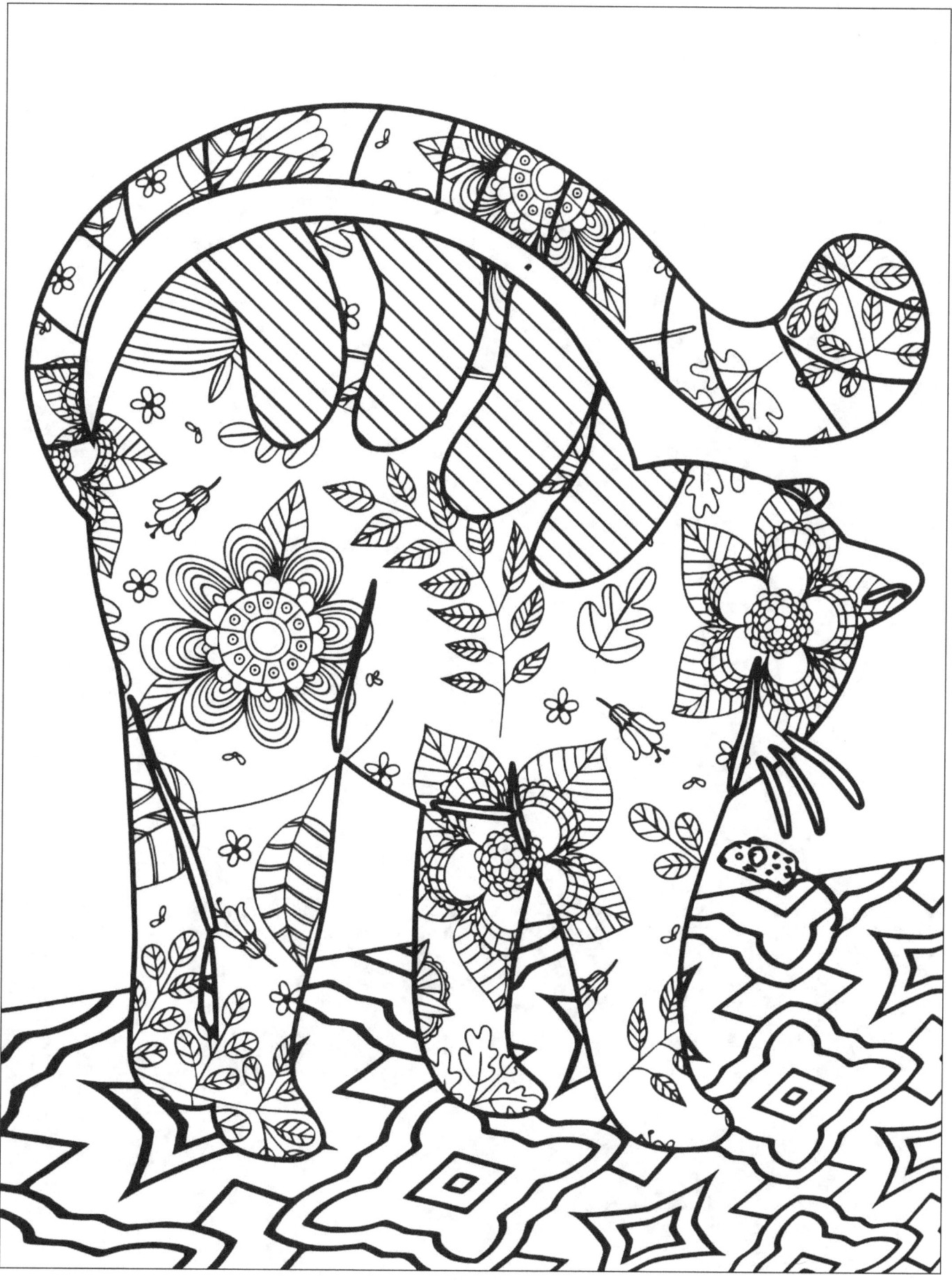

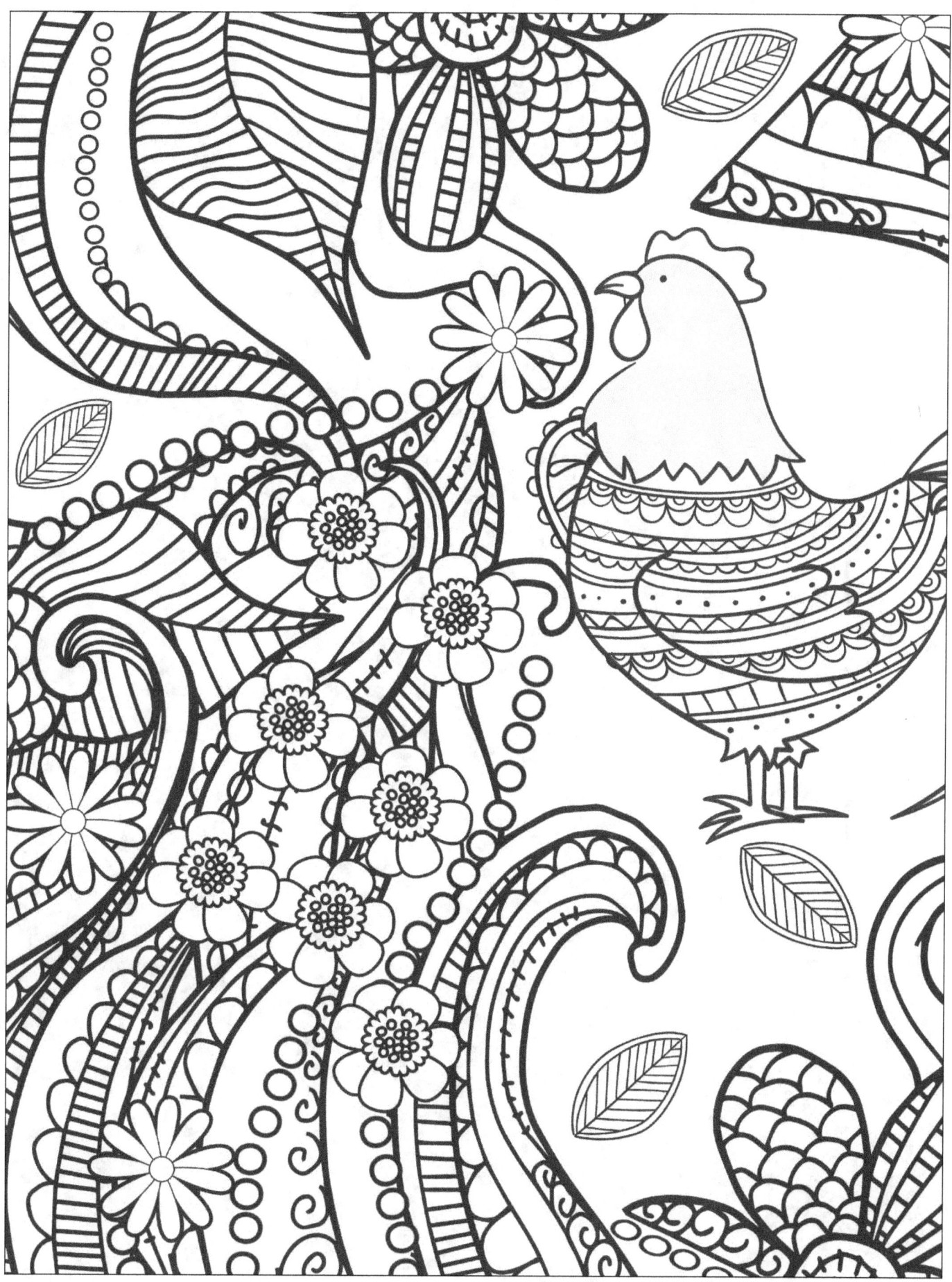

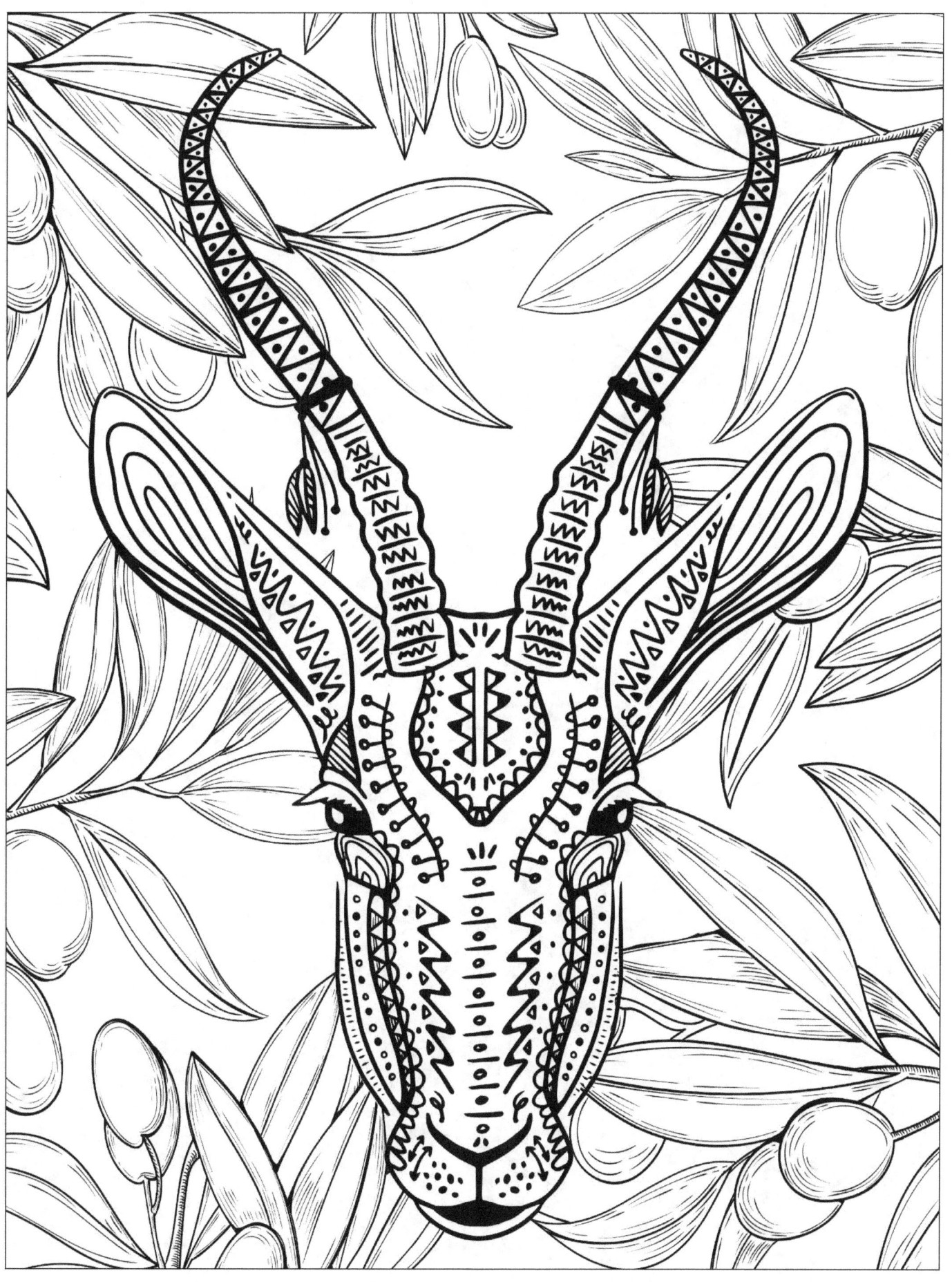

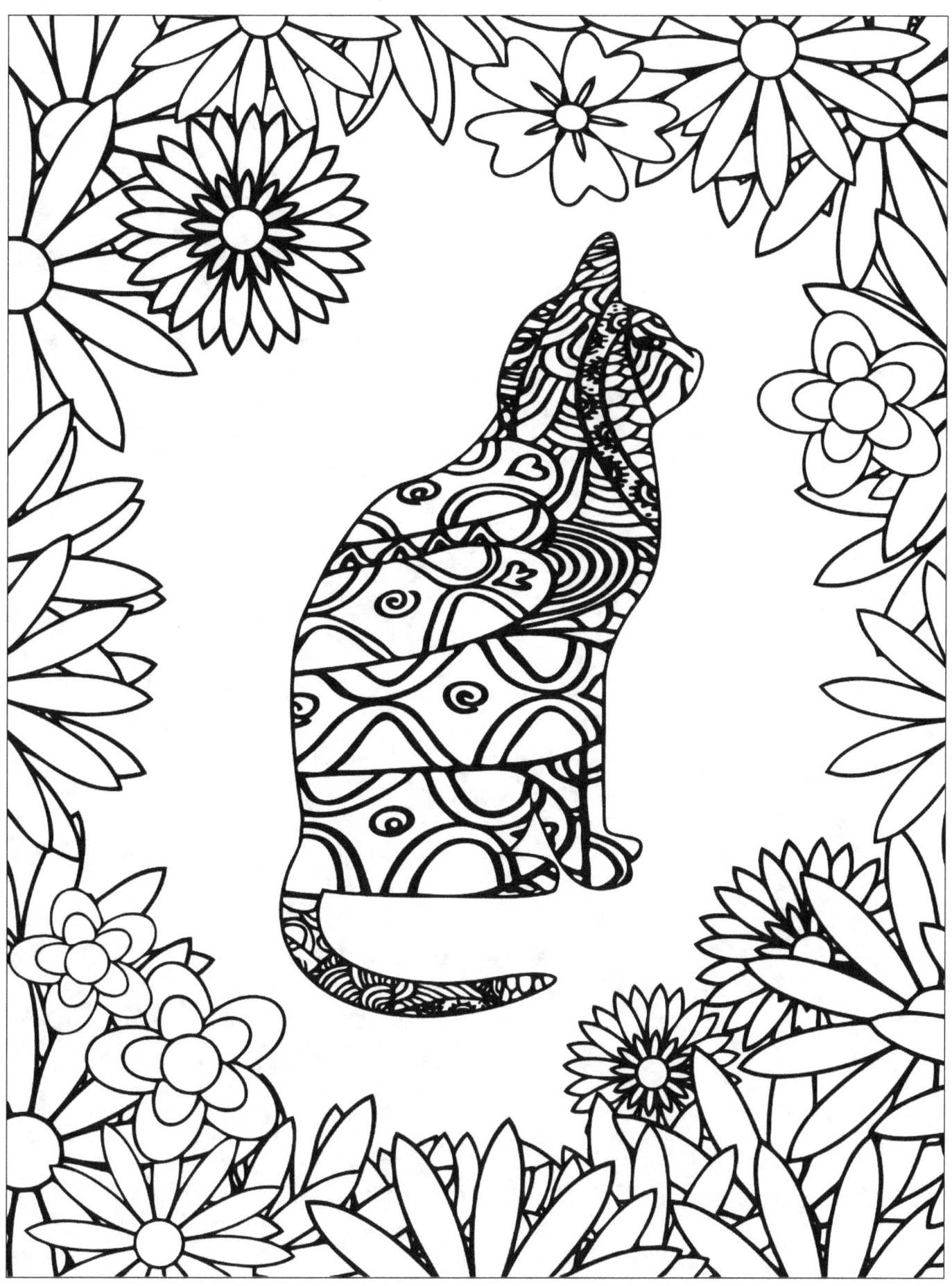

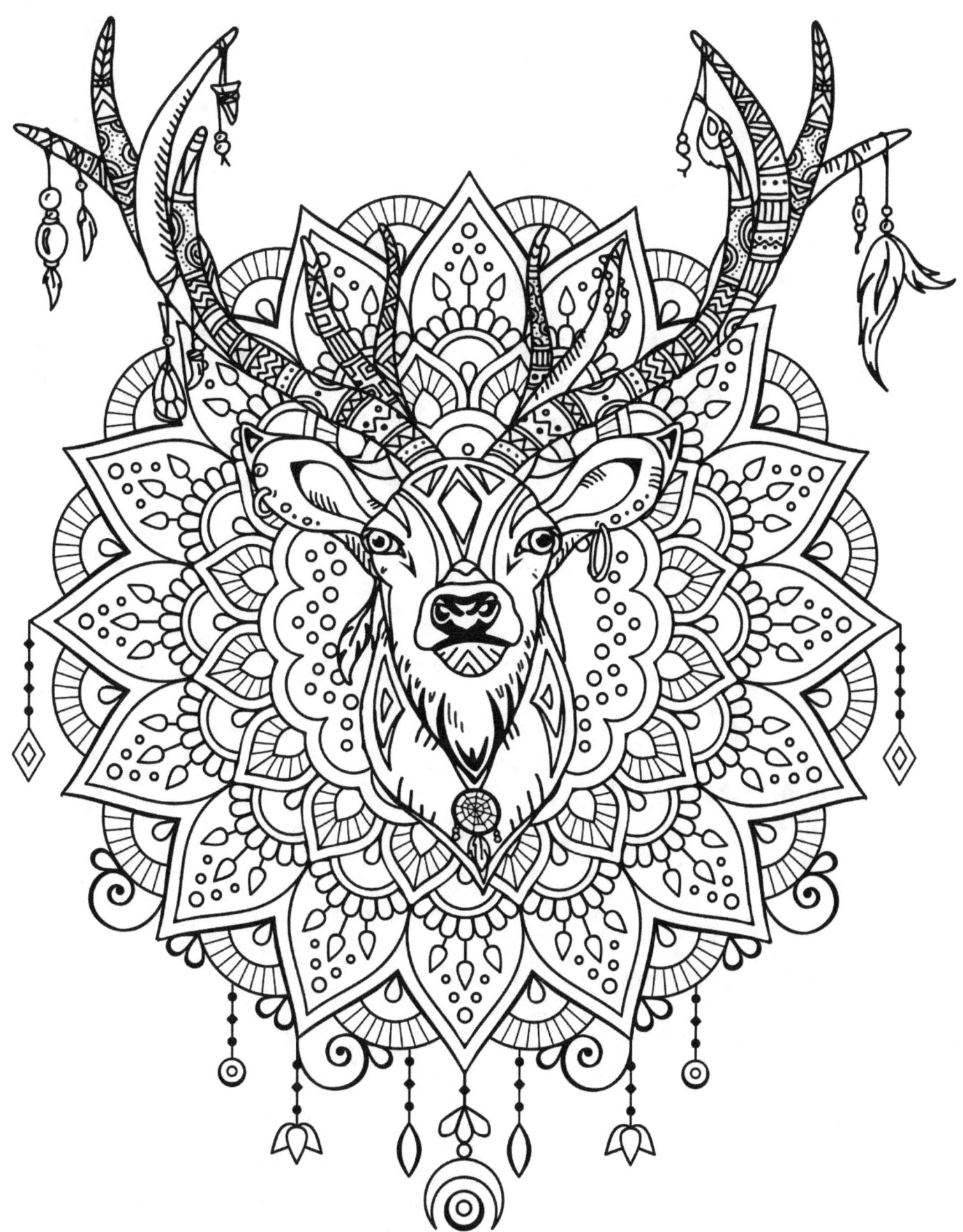

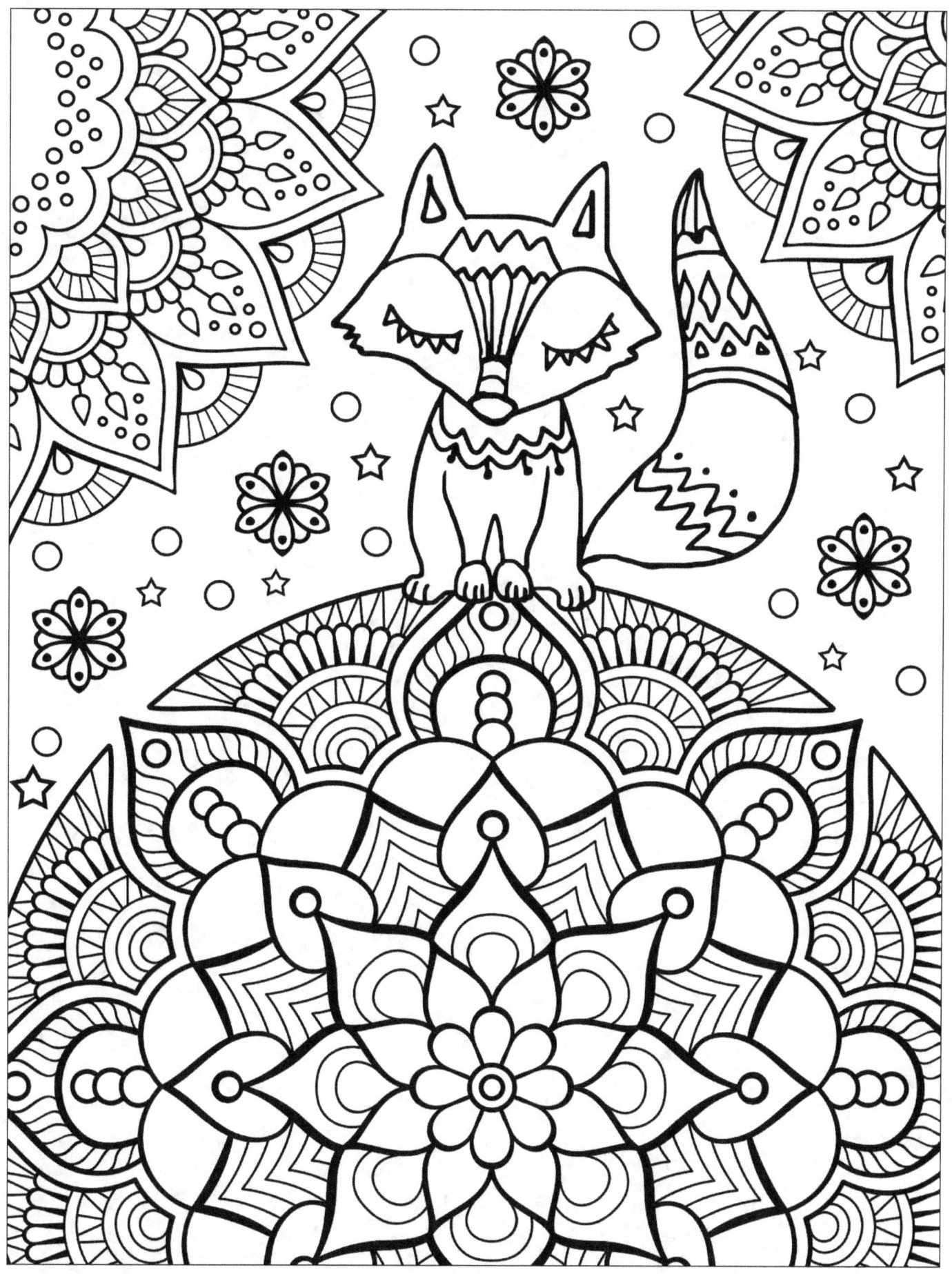

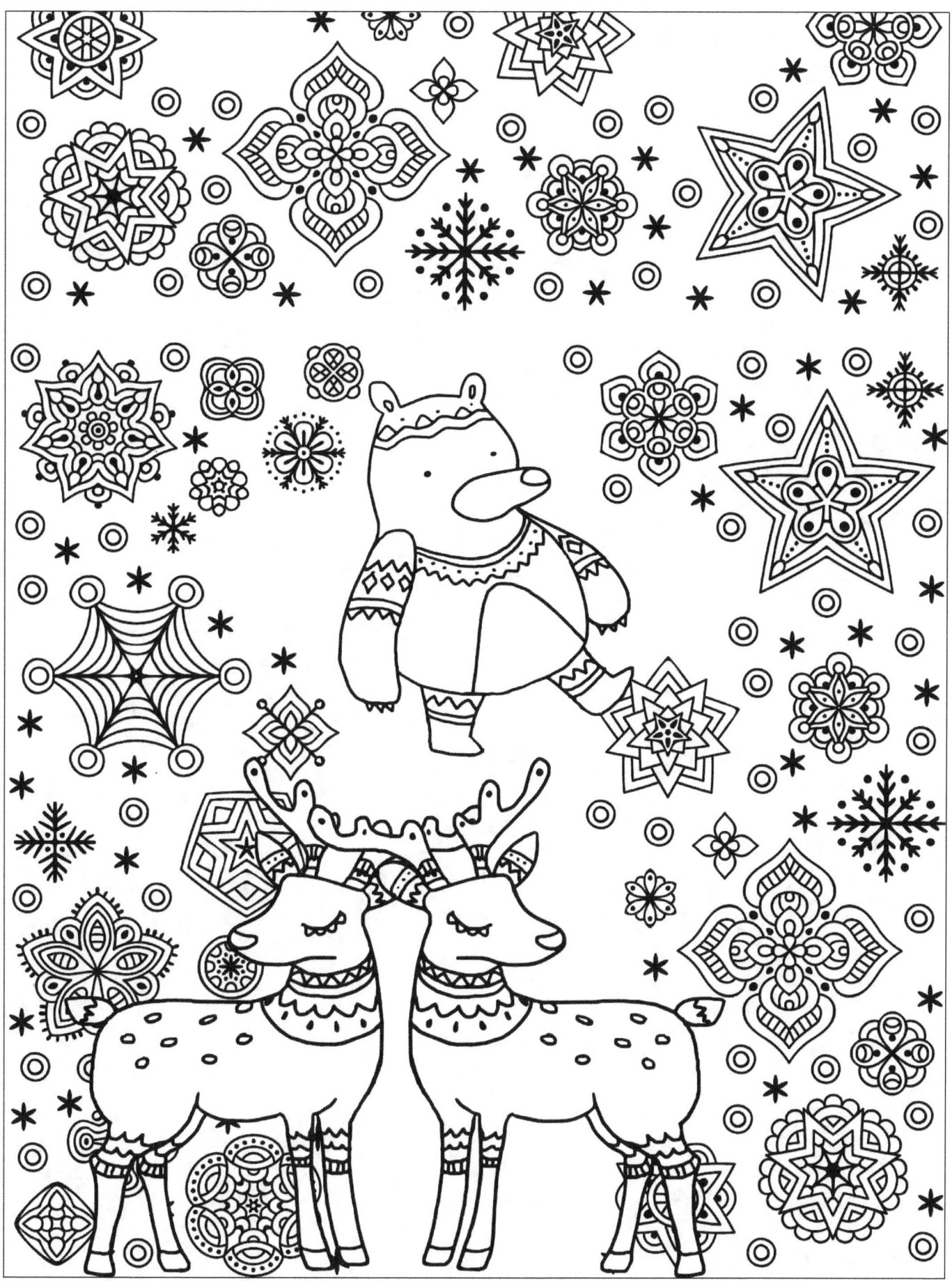

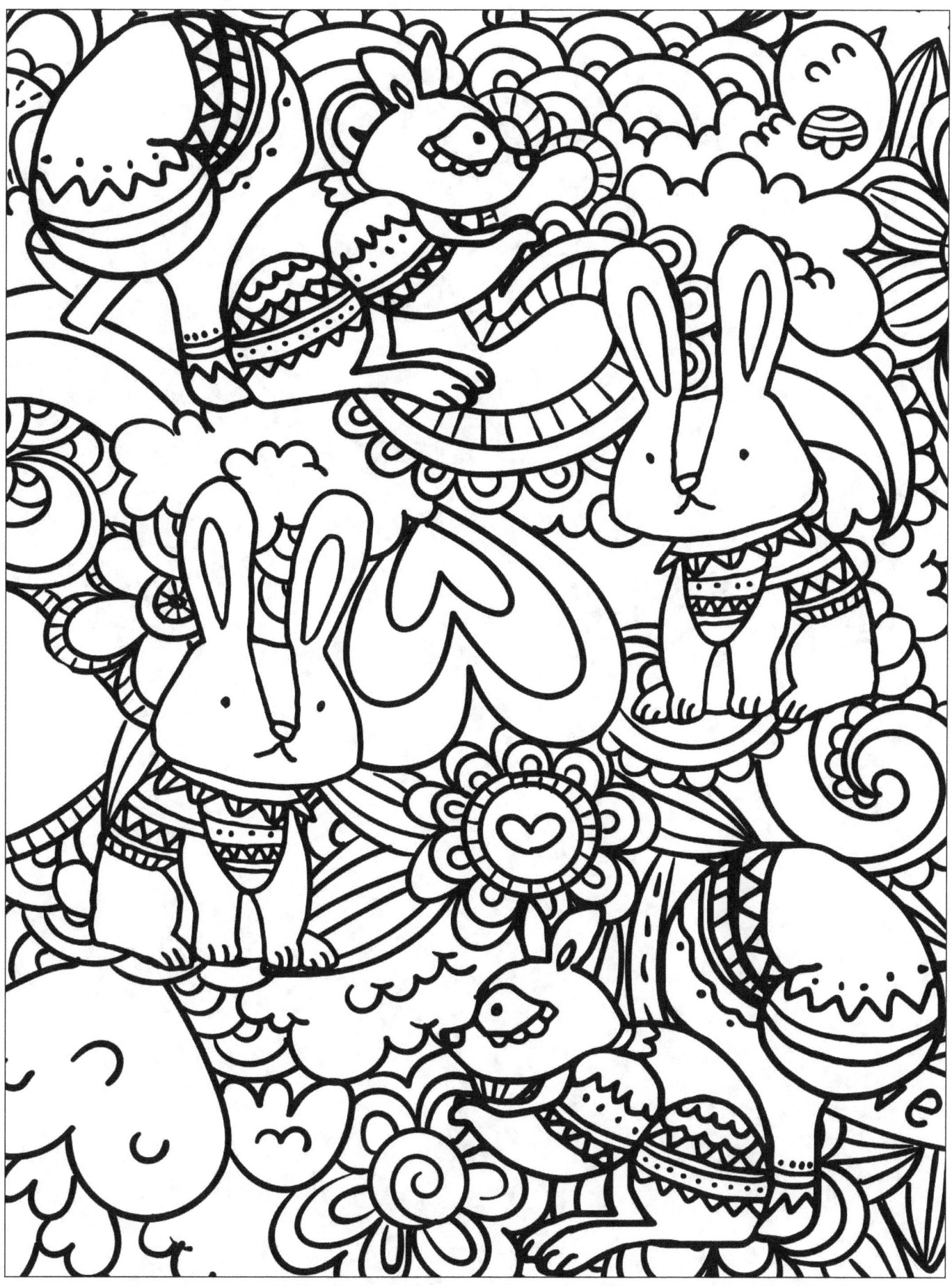

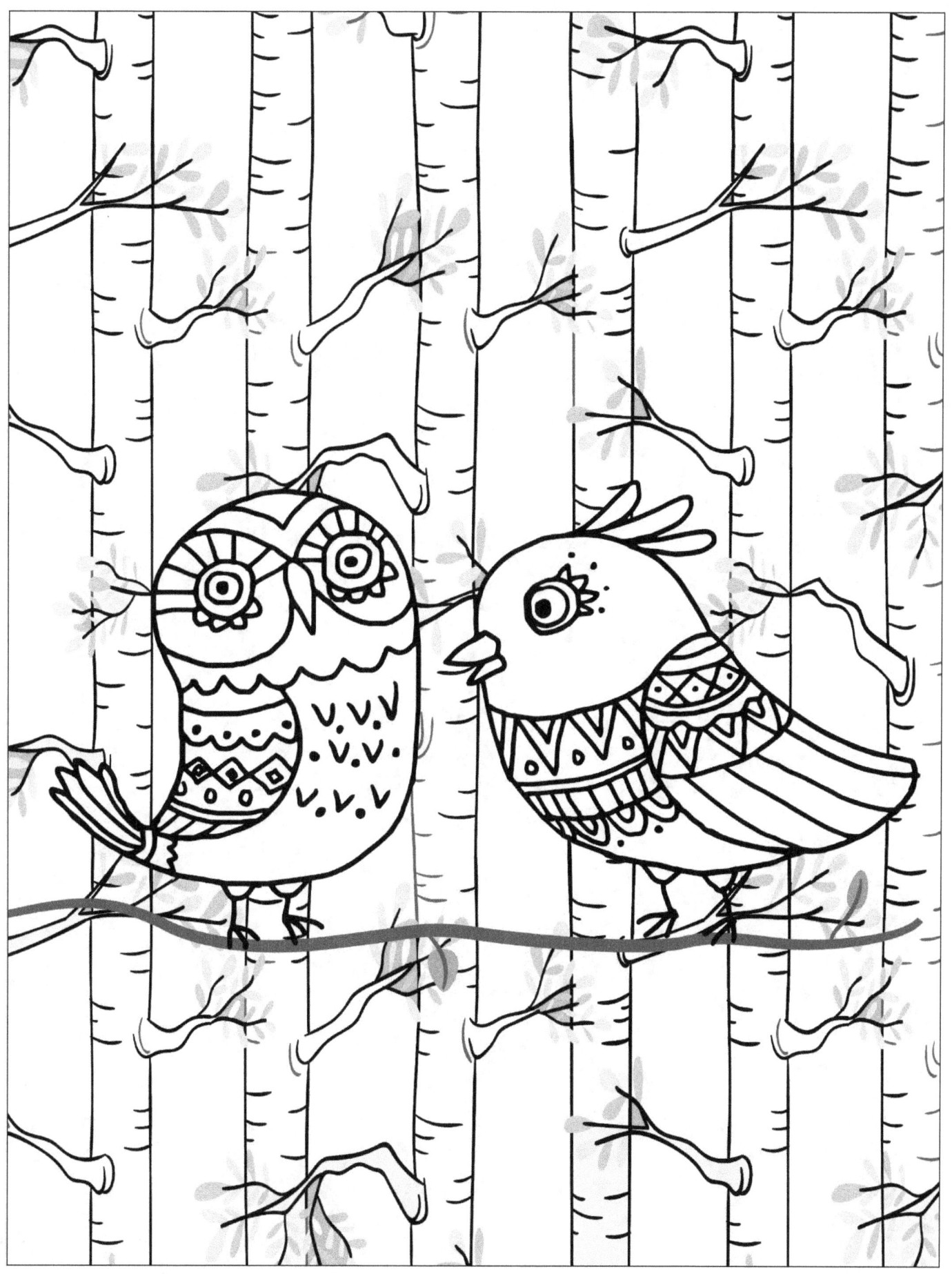

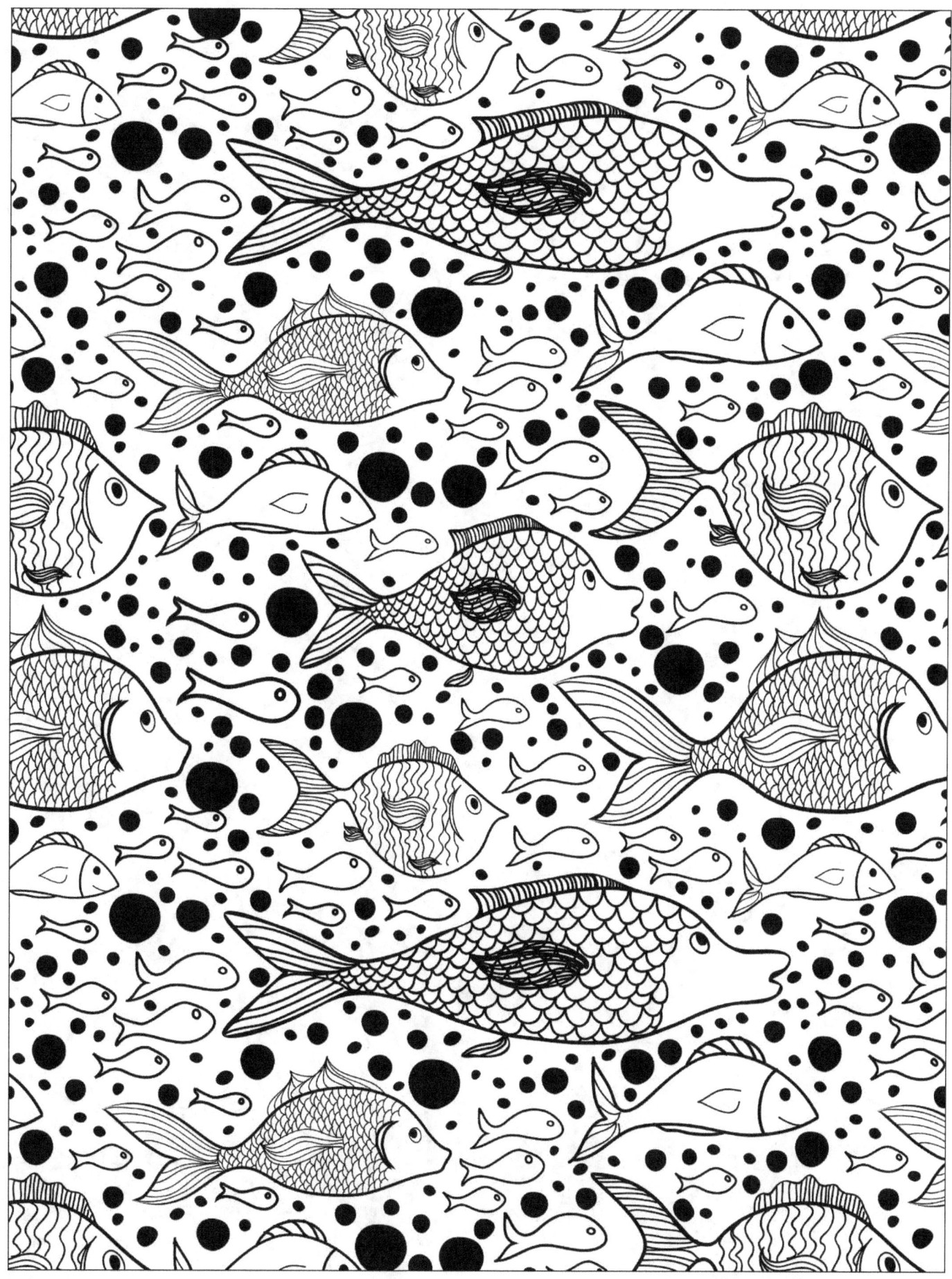

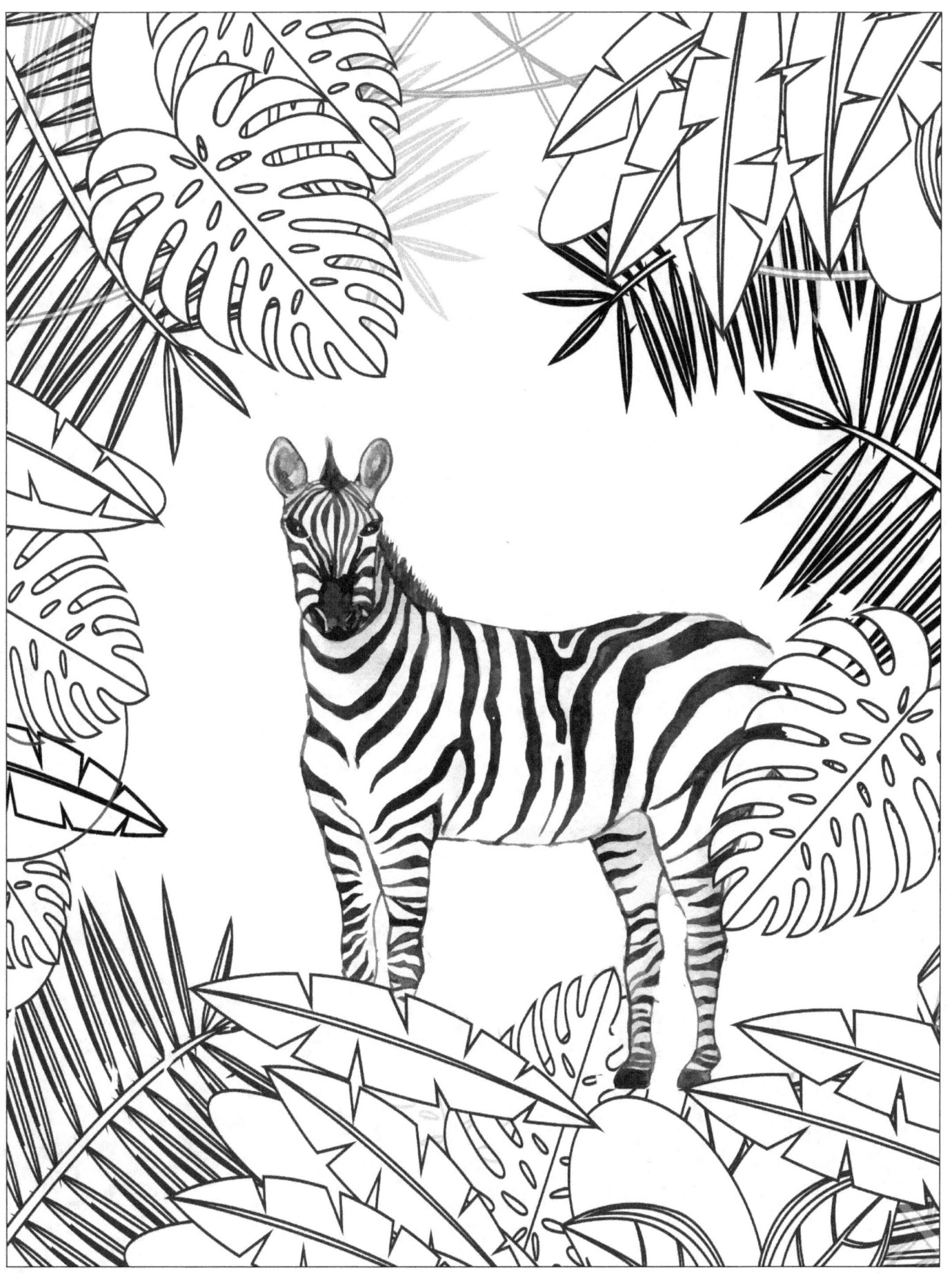

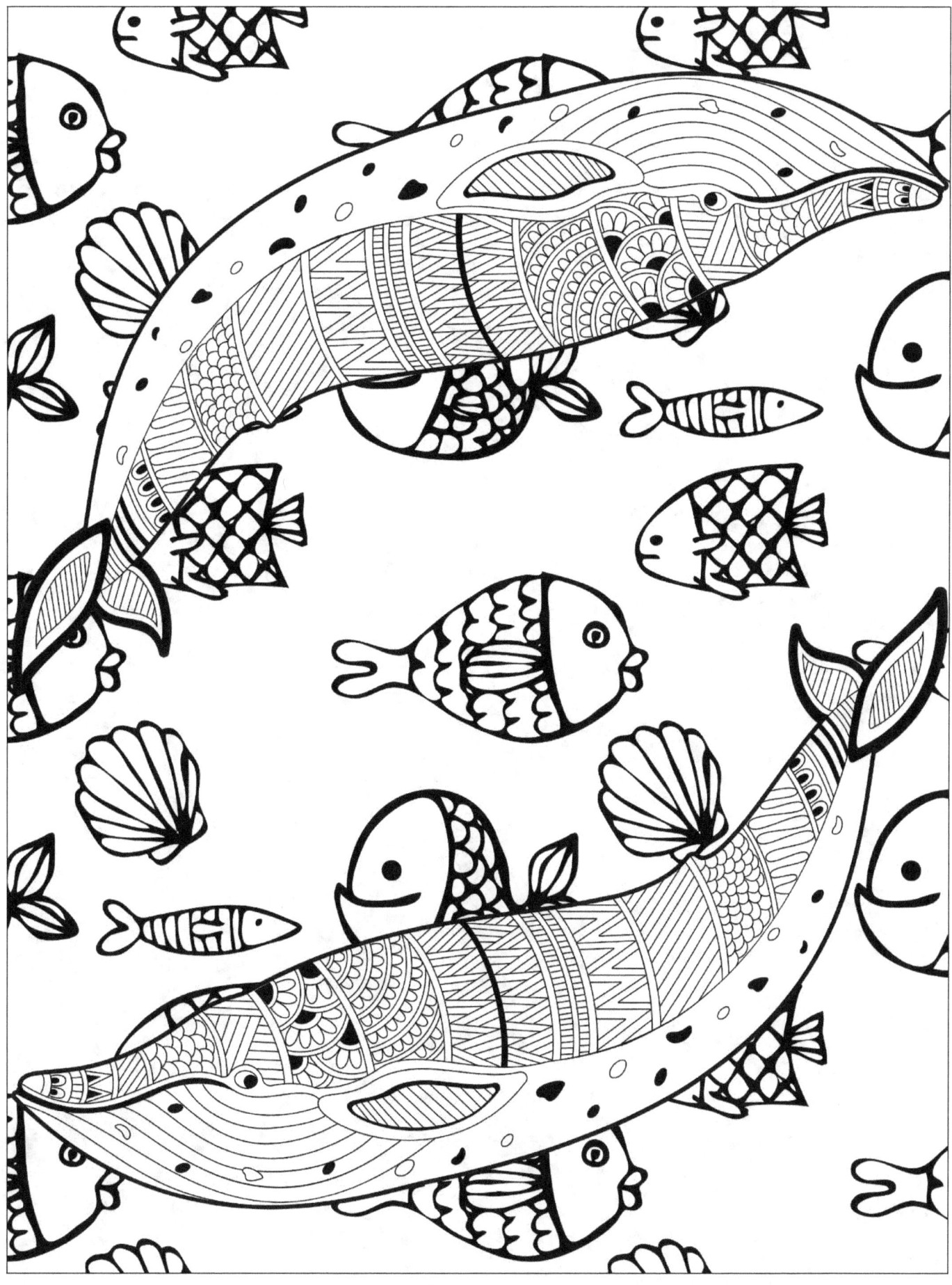

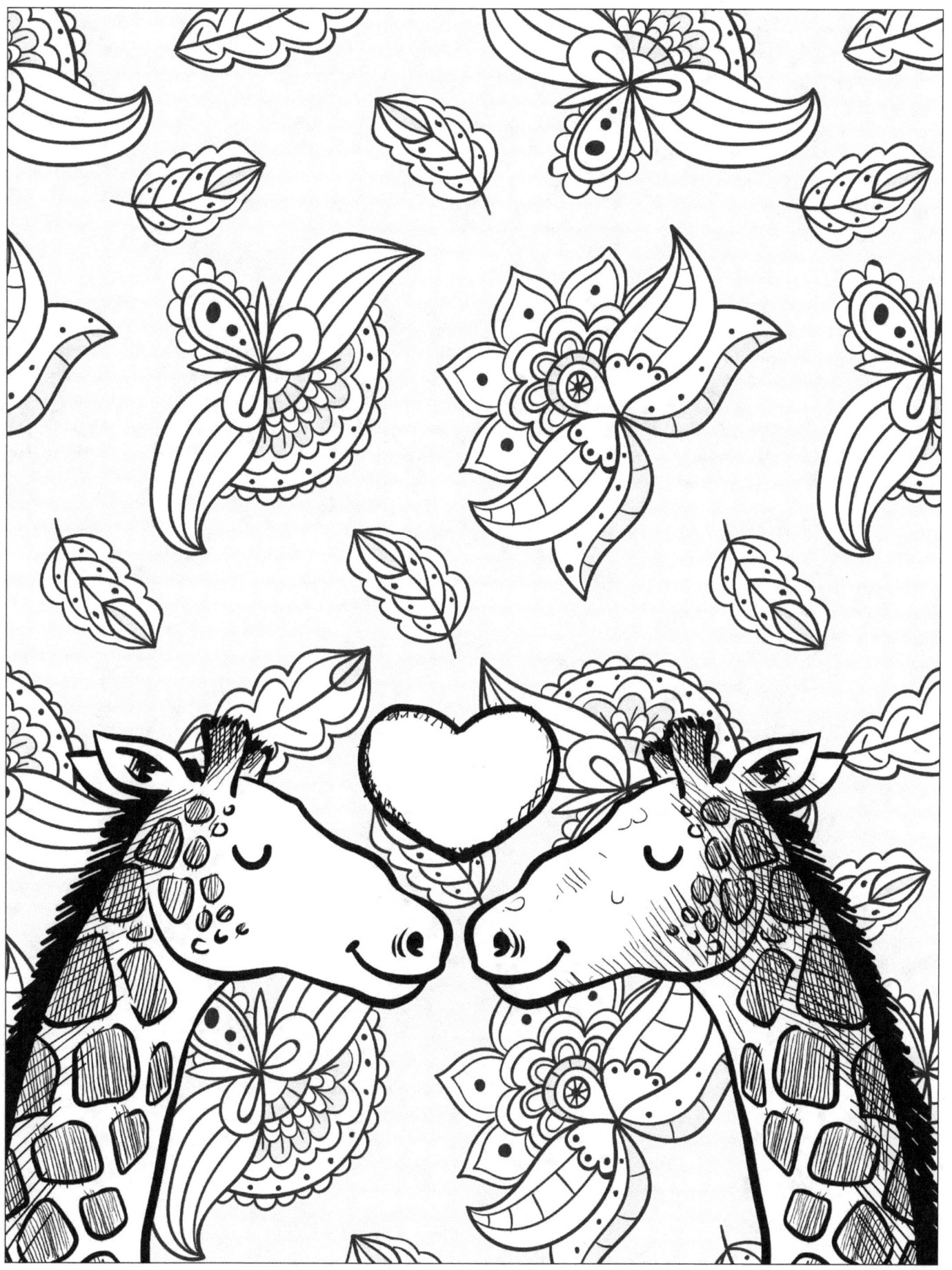

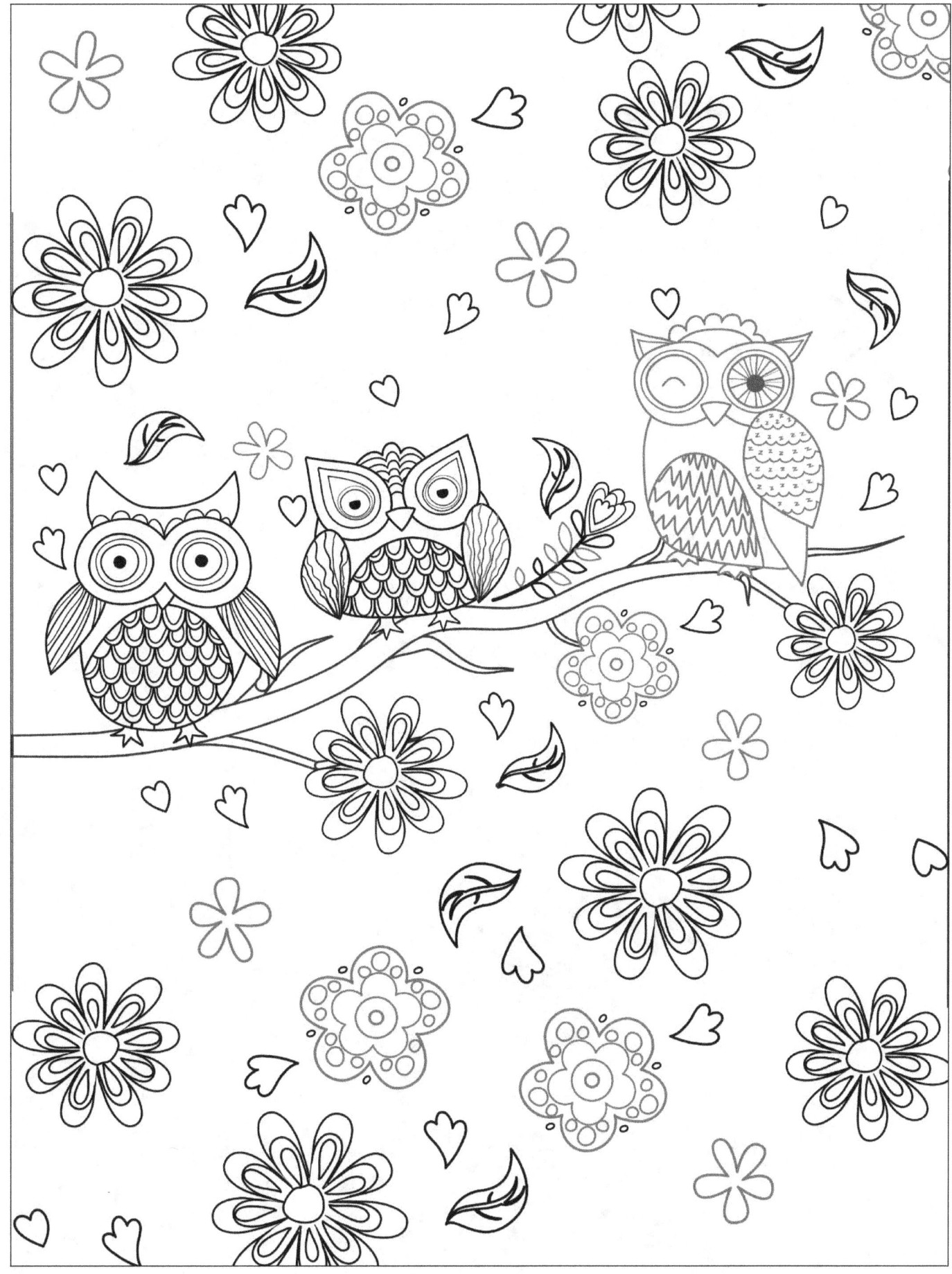

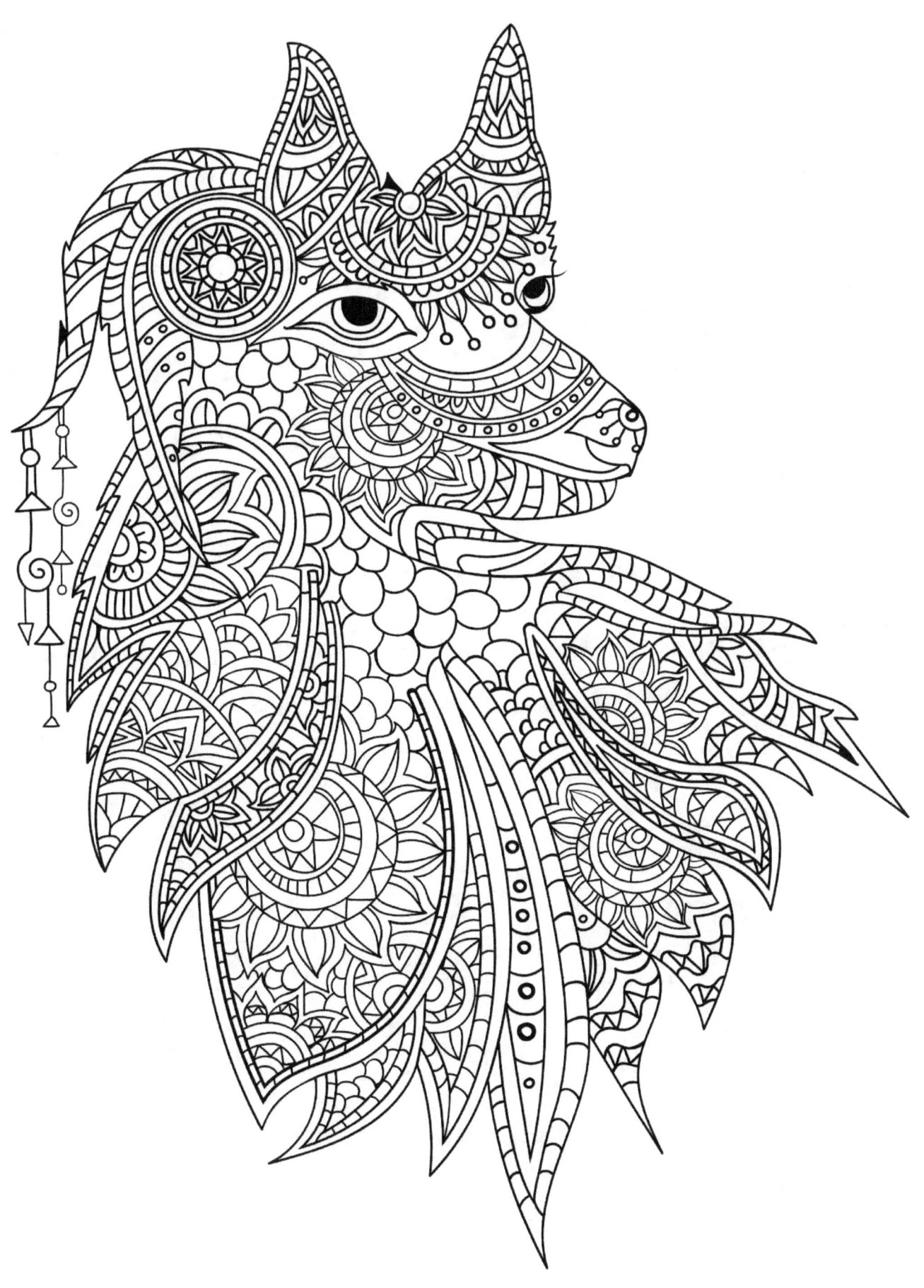

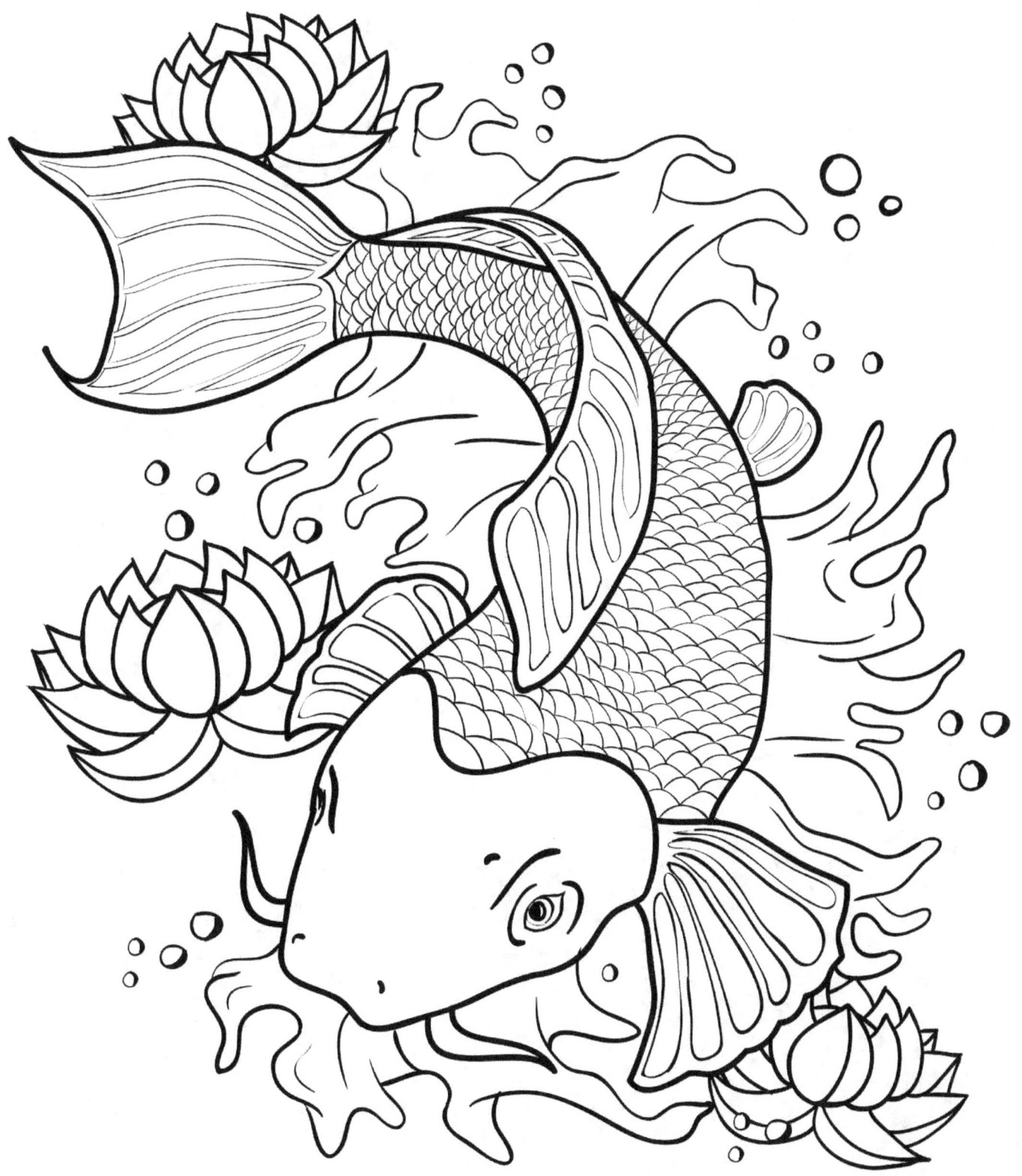

www.ingramcontent.com/pod-product-compliance
Lightning Source LLC
Chambersburg PA
CBHW081209180526

45170CB00006B/2273